CUTTING-EDGE
FASHION
ILLUSTRATION

Erica Sharp

David and Charles

www.stitchcraftcreate.co.uk

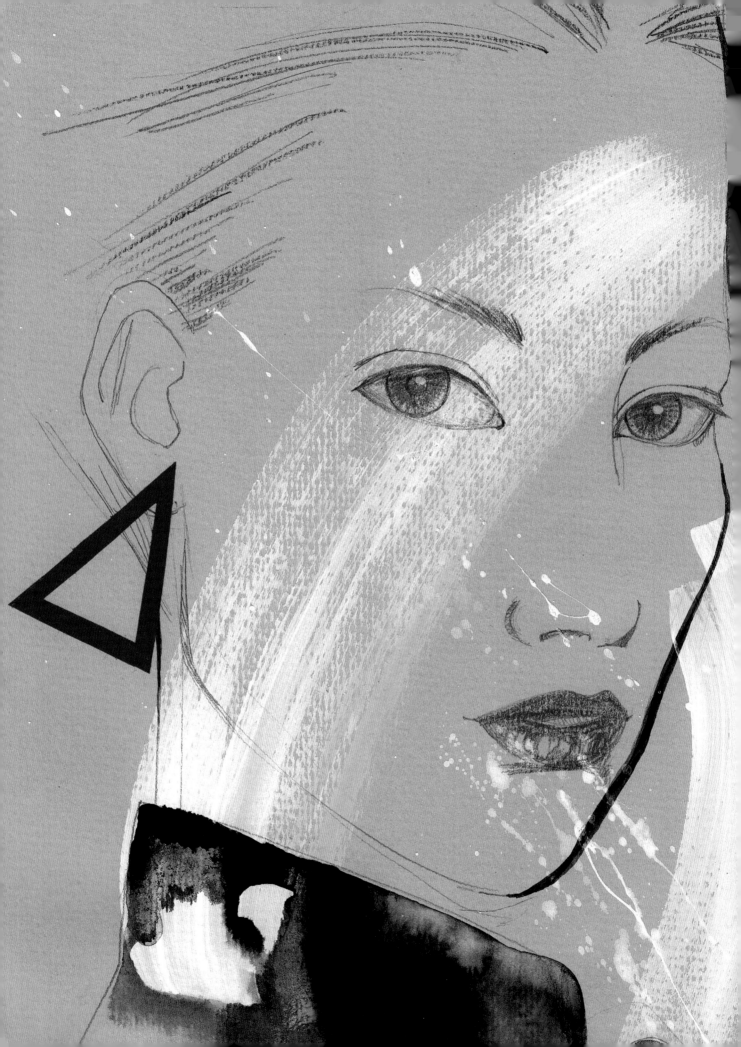

Contents

INTRODUCTION

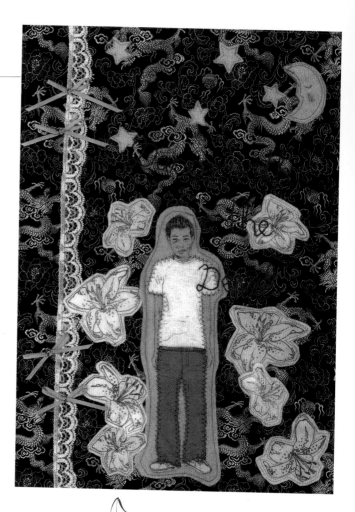

Welcome to *Cutting-Edge Fashion Illustration*. This book will guide you through the process for creating cutting-edge, contemporary fashion and beauty illustrations, combining a wide range of exciting materials and techniques with Adobe Photoshop. Whether you are a budding fashion designer or illustrator, or simply wish to learn more illustration techniques using Adobe Photoshop, this book should inspire you to learn something new in a fun and creative way.

Here each chapter covers a range of themes, from the fundamentals of Photoshop, to combining colour, texture and mixed media with your fashion illustrations. Within each chapter is a series of techniques; each of these demonstrated by a step-by-step tutorial followed by a gallery of inspirational images using that technique. If you are a beginner, I recommend that you start working through the tutorials in the first chapter, Fundamentals, as this contains some useful and basic exercises that will help you to familiarize yourself with using Photoshop.

I have always been a very visual person and feel that art is my most powerful and honest form of communication. I come from a mixed British and Japanese background, and the rich visual culture of Japan has heavily influenced my vision. Growing up, I would read manga comics and loved Japanese animation, as well as the cute, colourful characters of these mediums. I learned origami with my mother and grandmother, and the intricate patterns of Japanese paper and textiles always fascinated me.

My illustration work for my final degree show was created with fabrics that had been individually screen printed and appliquéd together. This intricate style of embellishment, and my love for figure and portrait drawing, led me into fashion and beauty illustration.

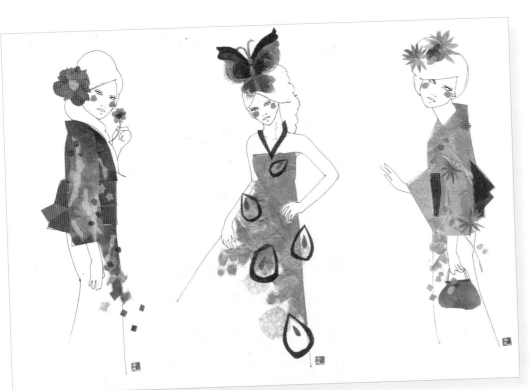

My hand-drawn illustrations feature collaged elements of traditional washi paper. The Japanese technique of kiri-e (paper cutting) has heavily influenced my non-digital fashion illustration work.

My love for drawing led me to complete a degree in illustration at university. During this time of study, I had the opportunity to explore exciting media like screen printing, which was the focus of my final major project. I created screen-printed illustrations on fabric, which I then pieced together for appliqué and embellishment. This style developed into fashion illustration, and after graduating I purchased my first Apple Mac computer. Having no prior knowledge of Photoshop meant that I had to teach myself, but this was good for me as it meant becoming very experimental and unconventional in my approach.

Following my university degree, I became very proactive in entering competitions, submitting my work to group art exhibitions, and offering to illustrate for emerging magazines and companies regardless of the pay, just for the exposure. I had a day job alongside these activities and as my style of work developed, I gradually started to build more contacts in the world of fashion and editorial illustration, and began to work on paid commissions. I later travelled to Japan and worked there for three years, freelancing and illustrating for various magazines, clothing companies and books.

I created this book with the hope that it will inspire readers to become confident in using Photoshop, and to show that it can really work in your favour to create an exciting range of fashion work. I hope that my tutorials are useful, and that my illustrations inspire you; and as you work through each chapter you gain further confidence to adapt the skills and techniques outlined to suit and develop your own style of work.

My work has varied from editorial illustrations for magazines, to clothing graphics and book illustration.

DIGITAL
EQUIPMENT

In order to create and enhance digital and mixed media fashion illustrations, you will need the equipment I have listed here. Some items are not absolutely essential, such as the graphics tablet or digital SLR camera, however I personally find all these items incredibly beneficial in helping me to create work to the best professional standard.

GRAPHICS TABLET

Although it takes time to become used to working with one, a graphics tablet makes using Photoshop and other creative applications much easier and more natural. A graphics tablet consists of a digital tablet and a pen, enabling you to draw digitally in Photoshop in the same way you would with a regular pen and paper; it also allows you to navigate your workspace, as you would normally do with a mouse. A graphics tablet is usually pressure sensitive, so it also makes the whole creative experience much more intuitive and faster than using a mouse. Moreover a larger graphics tablet allows for even more precision, often making it well worth the investment.

COMPUTER

With the ever-increasing quality of digital photography and scanning technology, you will need a computer that can handle editing large images and files. So when purchasing either a PC or Apple Mac computer, it is worth investing in one with at least 8GB of RAM, as well as a generous hard drive for storage. RAM is required for open applications, and the more you have, the faster and more responsive your computer will be – especially when running multiple applications together such as Photoshop, Illustrator and a web browser.

SCANNER

As scanners are becoming much more affordable, a good mid-range model should be sufficient for scanning images at a decent resolution. An A4 (Letter) sized flat-bed scanner will allow you to scan your work in either black and white or colour, which can then be saved and worked on digitally.

DIGITAL SLR CAMERA

It is well worth investing in a good digital SLR camera to capture high quality images in terms of resolution and colour space. Most modern digital SLRs can take photos in the .raw format; although these images are much larger in comparison to a standard .jpg, they capture much more data at the point of shooting. This means that when you open a .raw image in Photoshop, you can use the additional colour and lighting data to adjust your image with far more precision and control.

PHOTOSHOP OVERVIEW

Each chapter in this book will demonstrate how to use different Photoshop techniques in your fashion illustrations, starting with fundamental tasks such as scanning and retouching an image, through to adjusting colour and adding scanned textures. To get you started, I've compiled an overview to the layout of Photoshop's workspace, as well as the various settings and tools that have been used the most in this book. Although the examples were created using Photoshop version CS6, many of the tools and settings are equally applicable to other versions of this software.

CMYK COLOUR SPACE

In this book we'll deal primarily with illustration intended for print output, so as a general rule it is best practice to set your document to the CMYK colour space. This refers to the common print process that uses four colours, cyan, magenta, yellow and black, which is commonly known as the four colour printing process. Make this setting before you begin any editing by selecting Image > Mode > CMYK Color. The alternative RGB option is a colour space for images used in screen displays only, such as websites or video design.

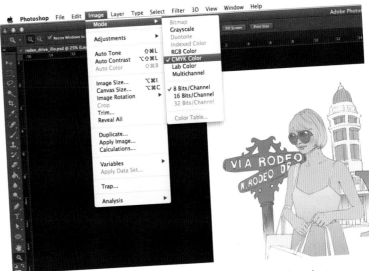

When you open an image in Photoshop, set the colour space option by selecting Image > Mode > CMYK Color (or RGB Color).

DOTS PER INCH

Another important setting when preparing a document on your computer for editing is the dpi or 'dots per inch' selection, which relates primarily to the print quality. The most commonly used option for print is 300dpi, so when scanning choose this setting to provide a good quality digital scan for manipulation; 72dpi is usually set for images intended for screen displays, such as on a computer monitor or television. As a general rule always set your artwork to 300dpi; you can always resize your illustrations to 72dpi later if you are uploading images to your website.

These images show a zoomed-in section of an illustration set at 300dpi (left) and at 72dpi. You can see the pixels are grainier at 72dpi.

PHOTOSHOP
WORKSPACE

Here we'll explore the Photoshop workspace, navigating our way through key areas such as the Tool palette, Colour palette and Layers palette, revealing the function of each area as we go.

1 Tool palette

This contains all the tools you will require to manipulate and adjust your image (see Photoshop Tool palette). There are many additional 'hidden' tool sets that can be accessed by clicking and holding on a selected tool.

2 Selected tool options

Once you have selected your tool, additional options relating to that tool appear in this menu bar. For example, when you select the Brush tool, you will have options to adjust its size and intensity in the menu.

3 Document information

Basic document information and the current magnification are shown here. Click on the arrow button for additional information, such as the document size.

4 Colour palette

You can select and mix colours using the wide variety of options in this palette, and by clicking on the drop-down arrow even more colour mixing options become available.

5 History palette

This displays a list of all the 'actions' performed whilst manipulating your image, which means that if you accidently erase part of your image you can step back to a previous stage. This palette is also useful for tracing back your decisions through the creative process.

6 Layers palette

This is one of the most important areas of the workspace, as one of the most powerful tools in Photoshop is the ability to add and work on different layers. By creating each element of work as a separate layer, you can then easily adjust individual elements without affecting the whole image. The Layers palette shows all the layers in your image: the layer at the top of the list is the one at the very front of your image, so the top layer in the illustration is generally the black outlines while the layers underneath are the range of colours visible.

When working with layers, it is important to always save your work as .psd files to ensure these layers are saved and the image is easily editable. Saving as a .jpg or a .tif file means that the layers will be compressed, making it impossible to edit work after it is saved; only save an image as a .jpg or a .tif file if the image contains no layers, or if you are 100 per cent sure the image does not require any further adjustments. I always save my illustrations as both .psd and .tif files, so I have a version of both. When sending work to clients or in emails, always send .jpg or .tif files, as these files are smaller and take up less memory.

7 Layers Tool palette

This small tool palette primarily enables you to create a new layer by clicking the New Layer icon, which is shaped like a square piece of paper. Here you can also create various different types of layers, other than the regular layers on which you create each part of your illustration. In this book we will use adjustment layers, paths and channels: these are different to regular layers as they help you to achieve a range of specific colour and drawing techniques, which are outlined in more detail below. In addition, you can delete any type of layer by dragging it into the Trash icon on this palette.

Create an adjustment layer by clicking on the half black and half white circle icon sitting at the bottom of the Layers Tool palette. Use this type of layer to make corrections to colour without affecting other layers, so if you decide to remove or adjust the colour correction you can simply delete or make changes to the relevant adjustment layer.

Use path layers for creating paths, which are made by clicking with the Pen tool to create a range of 'points' that connect together to form a shape or vector. Once a path is created, it can be filled with colours, gradients or textures using options within the Paths palette. Paths are useful because they allow you to create shapes that fit parts of your illustration in a precise way for filling with easily editable colour; the resulting vector shapes can also be enlarged without any effect on resolution. As long as each path is created in a new path layer, you can always go back and select an old path for editing.

Finally, channels are layers that store information about the colours in your illustration. So within the Channels palette the channels of a CMYK mode image will be listed as four separate colours, and each channel will also be listed differently in black, white and grey to show the placement of each particular colour. Use the options within this palette to create an alpha channel, which will mask out or protect and isolate a selected area from editing. In this book we create alpha channels as my preferred method to separate a scanned line drawing from its white background.

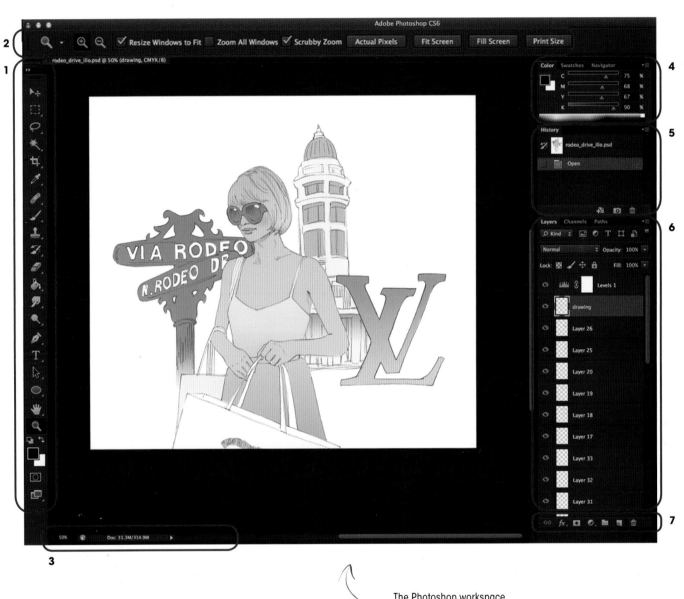

The Photoshop workspace showing the different tools, options and palettes.

PHOTOSHOP
TOOL PALETTE

The Photoshop Tool palette contains a range of tools that are essential for manipulating your images. The key tools are listed below, followed by some of their variations that can be selected by clicking and holding the mouse on the tool in question.

1 Move

Use this tool to move and transform (scale and rotate) your image.

2 Rectangular Marquee

- Elliptical Marquee
- Single Column Marquee
- Single Row Marquee

Use this tool to drag your cursor and select different areas of your image in which to work. For example, if you use this tool to create a rectangle selection, subsequent painting and effects will only be applied to areas within this selection.

3 Lasso

- Polygonic Lasso
- Magnetic Lasso

Another way of creating a selection, the Polygonic Lasso tool allows you to click and create points to form a geometric selection area. The Magnetic Lasso tool 'sticks' like a magnet around irregular shapes to help you quickly select them.

4 Magic Wand

- Quick Selection

The Magic Wand allows you to select an area based on its colour. Moreover Quick Selection is a very handy tool, as it creates a selection by reading the area's pixel value so you can quickly select an outline or any other object.

5 Crop

This tool allows you to drag your mouse over a section of your image to crop it.

6 Eyedropper

The Eyedropper allows you to pick specific colours from your image. When you click the Eyedropper tool onto a colour, it will automatically appear as your foreground colour then this colour can be applied using the Brush or Paint Bucket tool.

7 Spot Healing Brush

This can be a very useful tool that takes sections and copies their contents seamlessly, ideal for retouching blemishes, or painting complex textured areas such as grass or clouds. The Spot Healing Brush matches the exact colour, texture, lighting and transparency to the pixels being healed, resulting in a seamless repair.

8 Brush

- Pencil
- Color Replacement
- Mixer Brush

This is the most useful tool in your arsenal, as it allows you to apply colour to your image. There are many brush options available, including using different styles, intensity and opacity.

9 Clone Stamp

This allows you to select a source point then paint that source somewhere else on the image. It is particularly useful for duplicating objects, or for cloning a specific scanned surface, such as textured paper or watercolour.

10 History Brush

Use the History Brush to selectively restore colour, detail, saturation or other image attributes from an earlier stage in the image's history.

11 Eraser

This erases parts of your image, with the added benefit that you can adjust the intensity and opacity of the eraser applied.

12 Paint Bucket Fill

- Gradient

The Paint Bucket tool fills a selected area with colour, while the Gradient tool fills a selected area with a graduated colour.

13 Smudge

- Blur
- Sharpen

The Smudge tool allows you to blur, sharpen or smudge areas of your image.

14 Dodge

- Burn

The Dodge tool is used to lighten areas of an image, while the Burn tool will darken them.

15 Pen

A very powerful tool used to create editable vector shapes and lines. Vector shapes can be stretched or reshaped without losing detail.

16 Type

- Vertical Type
- Horizontal Type

Used to create any type with a variety of options such as font, colour and size.

17 Path Selection

Used to select and manipulate paths, which are vector-based shapes created with the Pen tool.

18 Rectangle

- Rounded Rectangle
- Ellipse
- Polygon
- Line

This tool allows you to draw and/or colour specific shapes and lines.

19 Hand

The Hand tool is used to move your image within your workspace. An easier way of selecting this tool is to hold down the space bar then drag your mouse.

20 Zoom

This tool allows you to zoom in and out of your image.

21 Foreground/Background Color Swap

Clicking on the arrow allows you to swap the foreground and background colour.

22 Colour

This is your main tool for selecting colours. The square at the front represents your foreground colour, while the square behind it represents the background colour. Simply double click on the square to bring up the very extensive mixing palette.

23 Quick Mask

This is a useful tool that can be used to quickly make selections and mask out areas for manipulation.

24 Image Windowed

- Full screen mode

This allows you to cycle through different image views. For example, if you have multiple image documents open, you can focus and view a particular work as a full screen image.

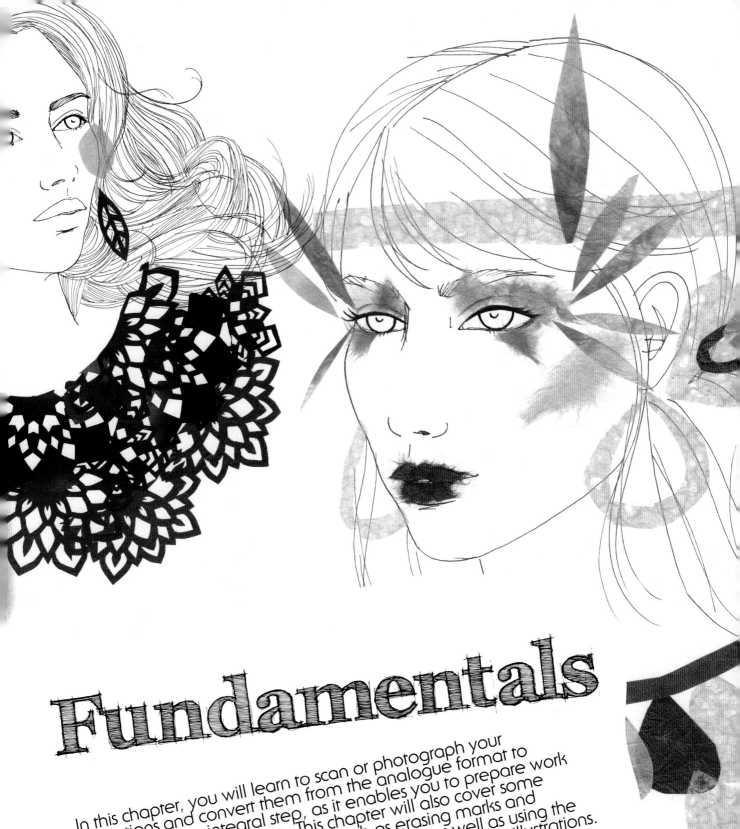

Fundamentals

In this chapter, you will learn to scan or photograph your illustrations and convert them from the analogue format to digital. This is an integral step, as it enables you to prepare work for both print and web use. This chapter will also cover some fundamental editing techniques such as erasing marks and blemishes, reformatting and cropping work, as well as using the Clone Stamp tool to retouch colour and texture in your illustrations.

SCAN, CLEAN AND RETOUCH A
FREEHAND ILLUSTRATION

This section will show you how to scan a colour illustration you have created on a white paper background. You will learn how to scan then clean up any blemishes on your work, as well as how to adjust the colour and contrast, to ensure your scan looks as close to the original illustration as possible.

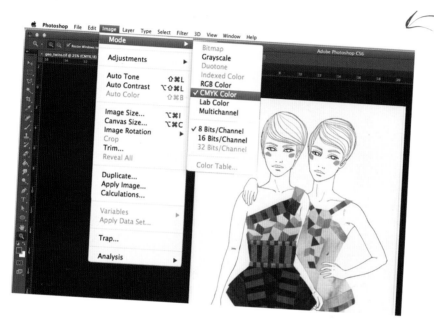

Place your freehand illustration on the scanner bed, carefully ensuring it is lying straight. Set your scanner to scan a colour photo at 300dpi then save as a .tif file once the scan is complete. Open the document in Photoshop by selecting File > Open. Adjust the Mode by selecting Image > Mode > CMYK Color: choosing CMYK as your default colour setting will ensure your illustration is in the correct mode for colour printing; if your illustration will also be used on a website, you can later switch to RGB.

Tip

When scanning, always ensure that the glass is free from dust or dirt, otherwise this will be picked up in the scanned image.

The first thing to do is to adjust the colour and contrast of your scanned image; you want the colour to look just as vibrant as it does in the original artwork. To do this, go to Image > Adjustments > Levels. Under Input Levels, move the outer dials in little by little, so they match with the outer edges of the fluctuating black graph (also known as a histogram); you are aiming to get the quality of line and colour as clear and crisp as they are in your original work. Ensure the Preview box is ticked so you can see the adjustments as you make them and once done, select OK.

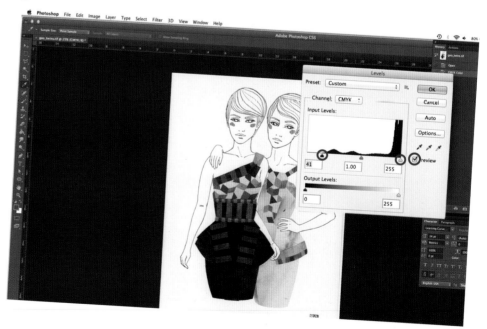

Once you have adjusted the colours under Levels, you may notice that the white background gains a slightly yellow hue, as shown in the previous step image. To correct this, select the Eyedropper tool on the far right of the Levels dialogue box then click on the image background. This will immediately adjust the background of your image to look pure white, as shown here.

Finally, use the Zoom tool to check for any marks or dust that may be visible on your illustration. You can easily move around zoomed areas by using the Hand tool. Erase any blemishes on the white background by selecting the Eraser tool; use it to simply rub out the areas you need to retouch. You can adjust the size and settings of your eraser by right clicking on your mouse/ graphics tablet pen. When completed, save as a .tif file.

Tip

A useful shortcut to access the Hand tool is to press and hold down the space bar whilst dragging your mouse to navigate your image.

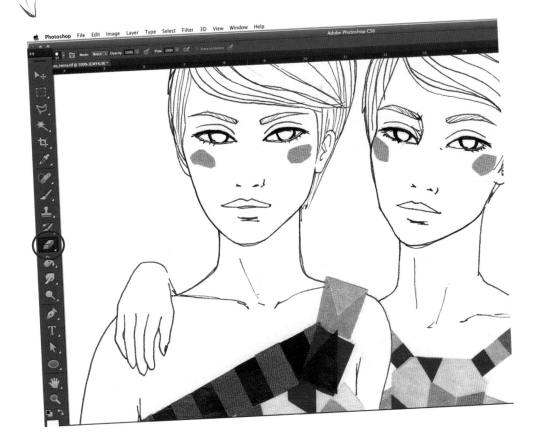

This piece was created by hand, using ink and collaged Japanese washi paper on a heavily textured white paper support, and required quite a bit of retouching to ensure there were no marks visible in the background. After scanning, the colour of the woman's cream dress was very light, so adjusting the colour balance helped to ensure it stood out and didn't get lost in the background.

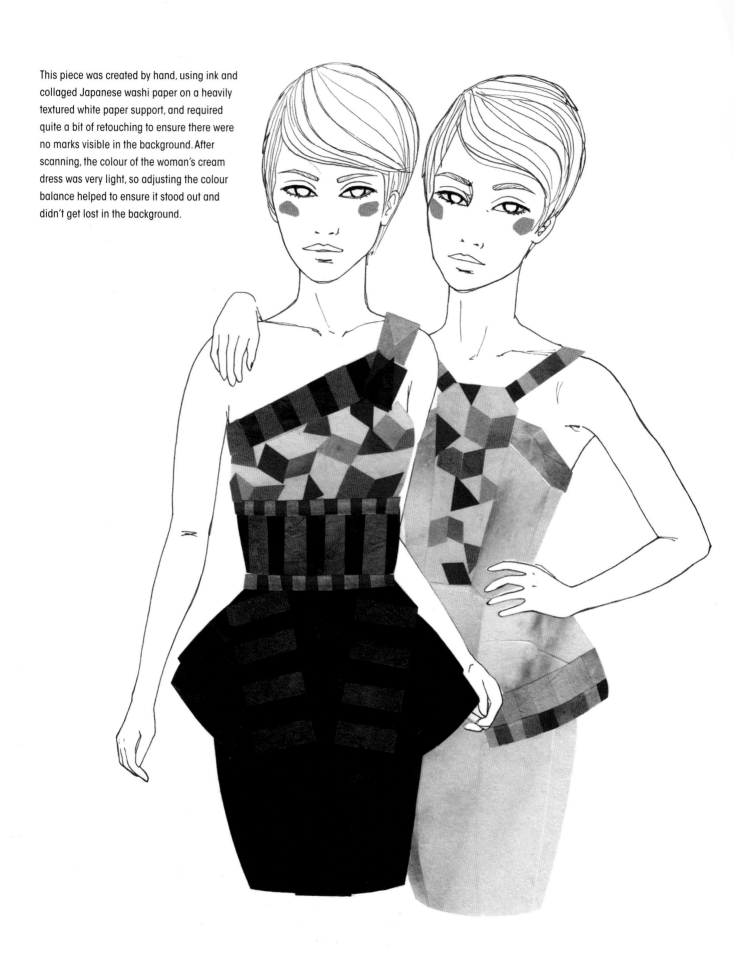

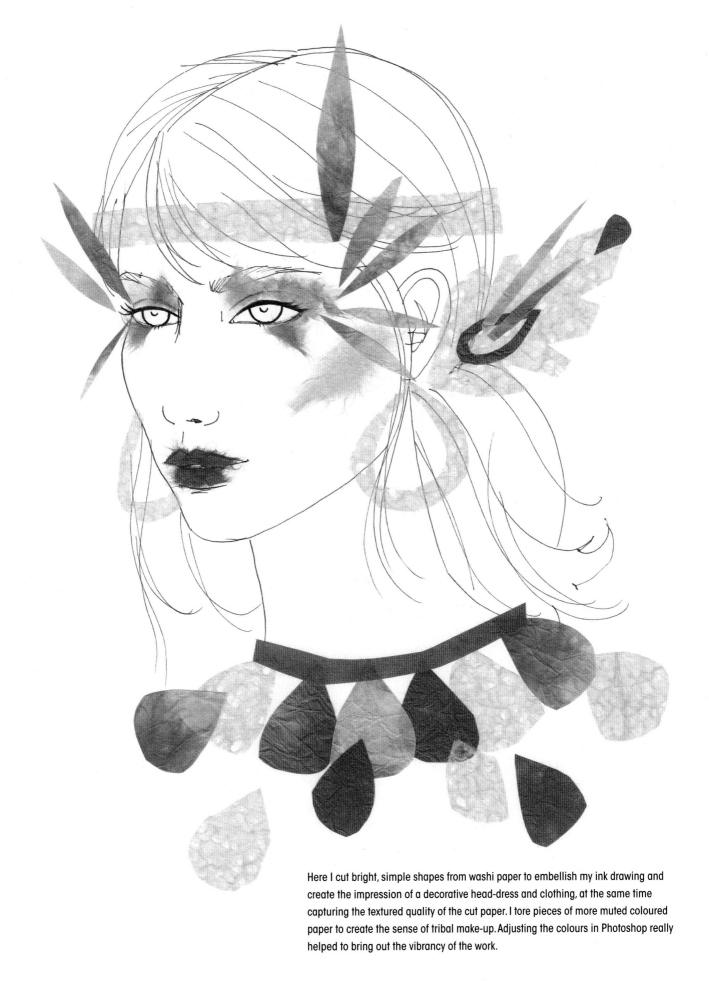

Here I cut bright, simple shapes from washi paper to embellish my ink drawing and create the impression of a decorative head-dress and clothing, at the same time capturing the textured quality of the cut paper. I tore pieces of more muted coloured paper to create the sense of tribal make-up. Adjusting the colours in Photoshop really helped to bring out the vibrancy of the work.

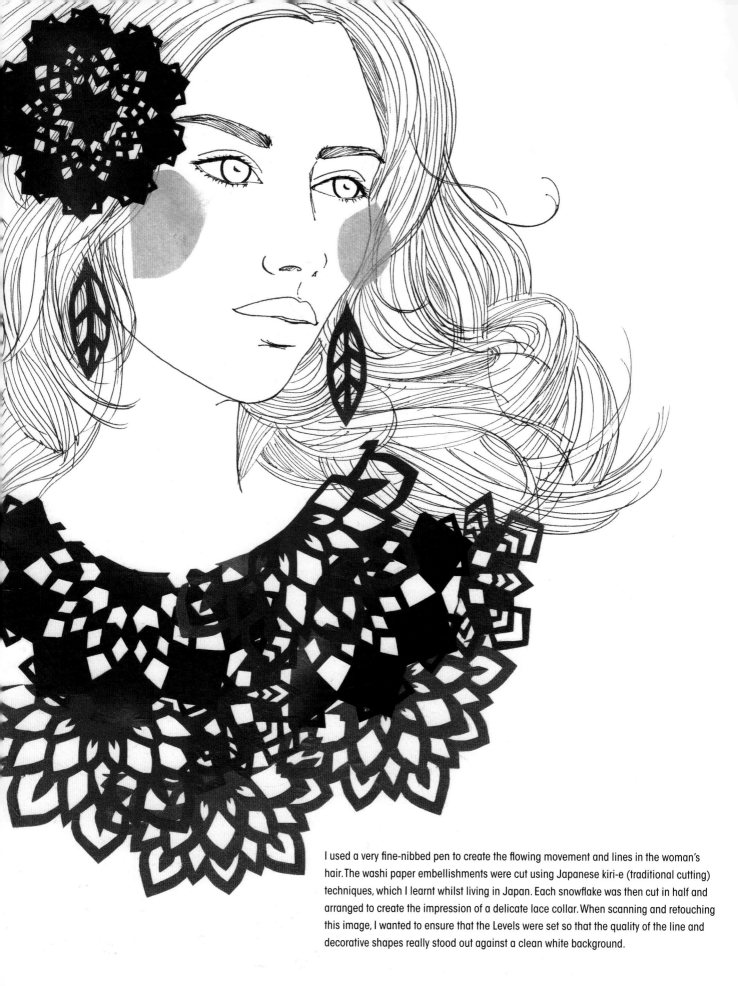

I used a very fine-nibbed pen to create the flowing movement and lines in the woman's hair. The washi paper embellishments were cut using Japanese kiri-e (traditional cutting) techniques, which I learnt whilst living in Japan. Each snowflake was then cut in half and arranged to create the impression of a delicate lace collar. When scanning and retouching this image, I wanted to ensure that the Levels were set so that the quality of the line and decorative shapes really stood out against a clean white background.

PHOTOGRAPH, CLEAN AND
RETOUCH AN ARTWORK

Here we'll work through the steps needed to photograph your illustrations so they are ready to crop and retouch. This is a particularly useful process if you work at a larger scale, and are therefore unable to scan the work. It is preferable to take photographs with a digital SLR, but a standard point-and-shoot digital compact camera can also work successfully. Using a tripod is essential whilst shooting to ensure the cleanest possible in-camera result, which will make your editing and retouching easier and more effective.

Photograph your artwork, using a digital compact or digital SLR camera, aiming to shoot the piece as straight on as possible. Upload your photo to your computer and open the image in Photoshop then convert it to CMYK mode by selecting Image > Mode > CMYK Color. Now use the Crop tool to crop out any unwanted areas around your image; you can rotate as you crop, which will help you reach as close to the edges as possible. Once you are happy with the area to be cropped off, hit Enter to actually make the crop.

Tip

Always ensure you use a tripod to shoot artworks, as this prevents any camera shake; at the same time, aim to photograph your work on a bright, sunny day in a room with lots of natural light to ensure you achieve a clear, crisp result.

Despite making every effort to shoot your illustration straight on, you will still most likely have a few edges and corners that don't quite fit snuggly into your canvas. To clean up these corners, choose Select > All then go to Edit > Transform > Skew. Drag the corners until the entire image fills the edge of the canvas. Hit the Enter key to apply these changes.

Select Adjustment Layers in the Layers palette, which is the half black and half white circle icon. From the options on the Adjustment Layers menu, select Levels. Move the outer dials to match up with the edges of the white graph, so the lines and contrast in your scan are as clear and crisp as they are in your original artwork.

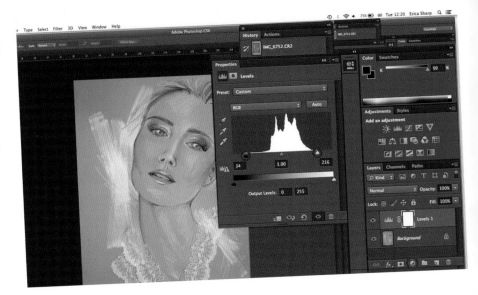

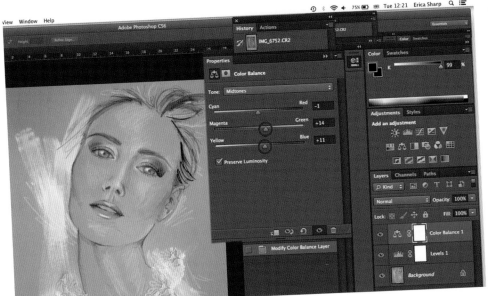

Next, select the Color Balance option from the Adjustment Layers menu then adjust the colours, so they are as close the original artwork as possible. For example, if the work looks a little too warm or yellow, adjust the cool blue and green colour dials to balance the colours in your work; similarly, if the colours look too cool, adjust the warmer yellow and red colour dials.

Tip

Observe the original artwork at the same time as you are adjusting the Levels and colour balance, and aim to create contrast and colours in your scan that are as close to the original as possible.

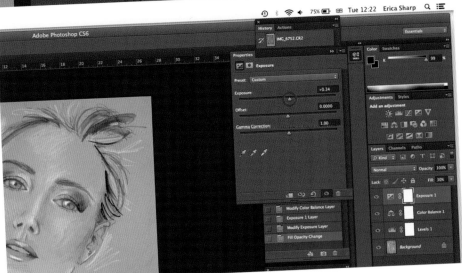

Finally, if your scan still looks a little dark, select the Exposure option from the Adjustment Layers menu and adjust the Exposure slider until the exposure is correct. Save your image as a .psd file to ensure your layers are saved and the image is editable; you can save it as a compressed .tif file later.

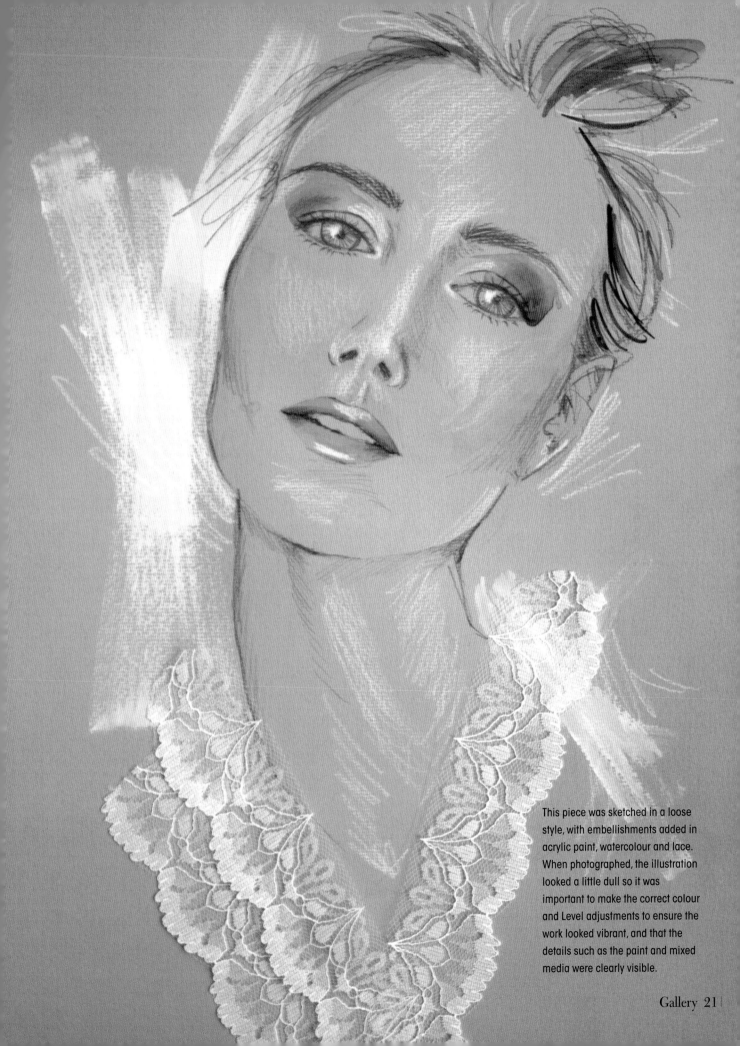

This piece was sketched in a loose style, with embellishments added in acrylic paint, watercolour and lace. When photographed, the illustration looked a little dull so it was important to make the correct colour and Level adjustments to ensure the work looked vibrant, and that the details such as the paint and mixed media were clearly visible.

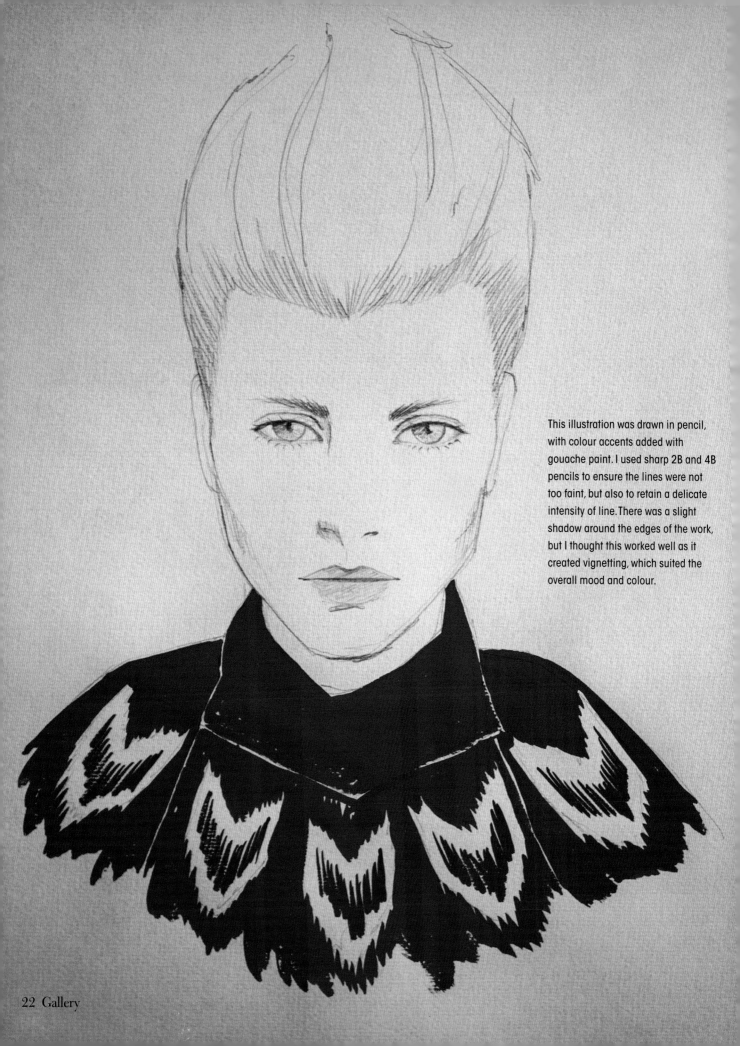

This illustration was drawn in pencil, with colour accents added with gouache paint. I used sharp 2B and 4B pencils to ensure the lines were not too faint, but also to retain a delicate intensity of line. There was a slight shadow around the edges of the work, but I thought this worked well as it created vignetting, which suited the overall mood and colour.

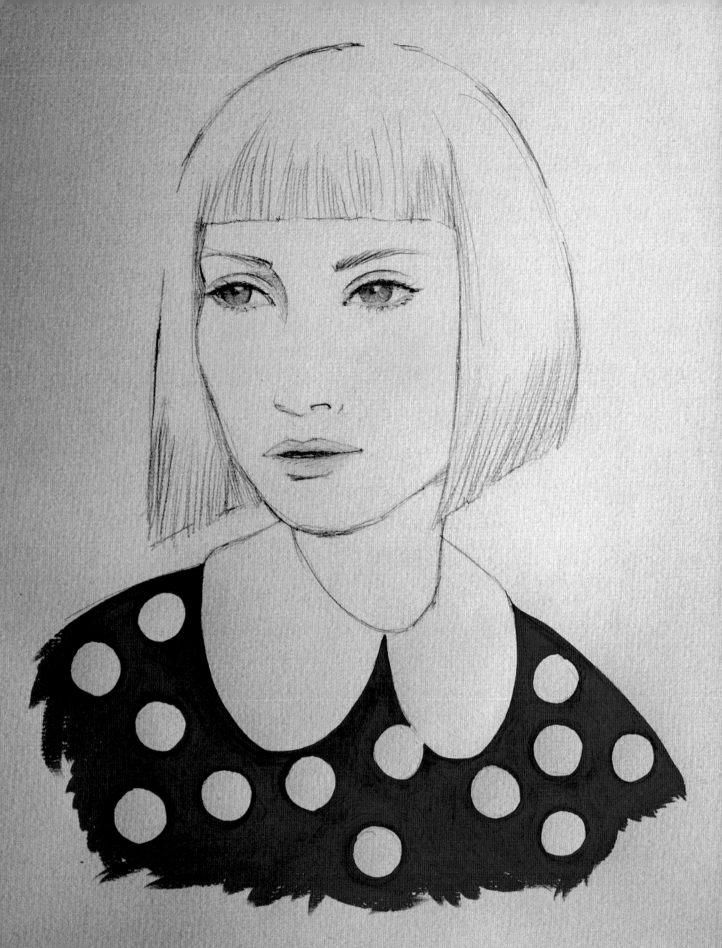

This piece was drawn with a mechanical 2B pencil, with added elements of colour pencil and gouache paint. Good lighting ensured it was photographed well, despite the subtle quality of line. The colours and Levels needed slight adjustments in-computer to ensure the piece retained the cool colour scheme of the original work.

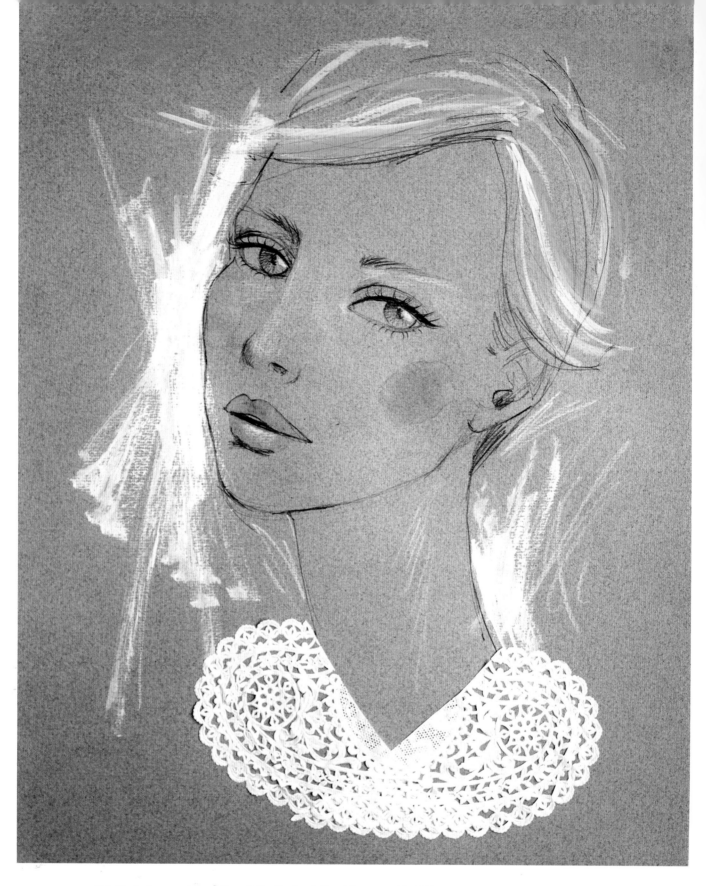

This illustration was drawn with realistic attention to the girl's eyes and facial features, but with looser mark-making around her face. I added white chalk and acrylic paint to accentuate the sense of movement around her, and I used a paper doily cut in half to create the collar. Due to the dark colour of the paper, this piece came out quite dark in the photograph. It therefore needed Levels and Exposure adjustments in-computer to ensure the sketched lines were not dominated by the dark background colour.

RETOUCH AN ILLUSTRATION
USING THE CLONE STAMP TOOL

Often you will create illustrations on coloured or textured paper, or may have more complicated colour details that need delicately retouching. You'll find that the Clone Stamp is an excellent tool for delicately retouching or cleaning up coloured or textured areas.

Open your scanned illustration in Photoshop then adjust the Mode by selecting Image > Mode > CMYK Color as your colour setting. Now click on the Adjustment Layers icon and select Levels. On the histogram, adjust the outer dials to alter the contrast and tone of your work for editing. The contrast in my scanned artwork appeared rather weak, so the Levels needed adjusting to make the drawing more visible against the background. In addition, you can click on Adjustment Layers and choose Color Balance to adjust the red and yellow dials if your work looks too cool, or the blue or green dials if your work looks too warm. This is not an essential step; the colour of my work looked a little warm, so I adjusted the blue dial a fraction.

Here there are a few areas with scruffy pencil lines and a splodge of ink to the right of the model's head that need removing. Owing to the textured background of the paper this is not possible with the Eraser tool, so use the Clone Stamp tool instead. This will clone a particular selected area, and apply the cloned area as directed to cover up and remove mistakes. Adjust the brush setting so it is a suitable size for removing the smudge or blemish; you will see that I have chosen the correct size to clean up the ink smudge by the woman's head.

Adjust the hardness of the Clone Stamp brush to ensure a seamless finish. For large areas, use a soft-edged brush so there are no visible edges to areas you clone; use a hard-edged brush for cleaning up around lines and more solid edges.

With a suitable brush size selected, hold down the Alt key and click on an appropriate area to clone; I chose to clone an area close to the ink smudge, so the colour matched as closely as possible. After selecting an area to clone, use the brush to cover up the smudge or blemish bit by bit. If you have cloned an area close enough to the blemish, it should cover it seamlessly.

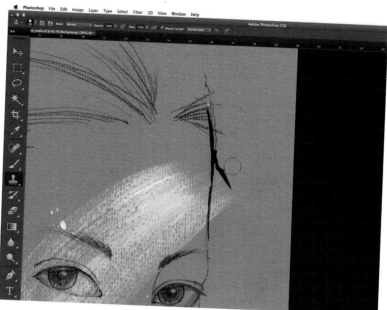

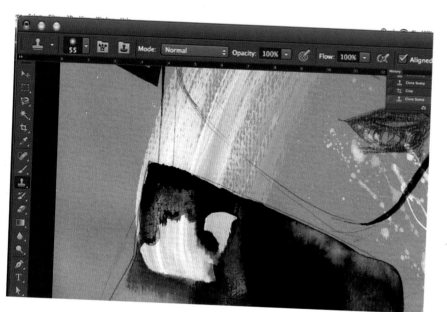

Repeat the previous step to remove some of the scruffy pencil lines, but don't remove every single pencil mark or blemish so you retain some of the illustration's hand-drawn quality. In this case the pencil line to be removed was long and straight, so it needed to be subtly covered. To do this, select a soft-edged brush, which is best suited for subtle work, then adjust the brush size to make it a lot smaller. After clicking the Alt key to select an area, cover up the pencil line little by little then use the same technique to remove any remaining pencil lines.

Finally, after saving the work, adjust the composition if necessary using the Crop tool. I cropped my work slightly from the top to adjust the layout.

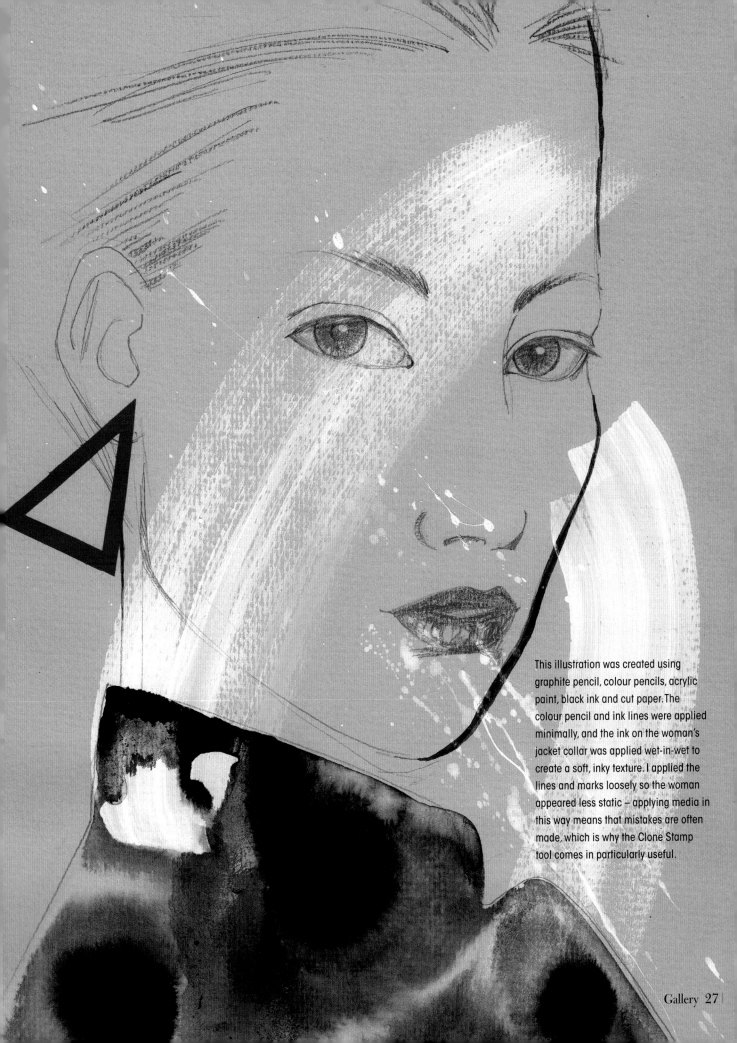

This illustration was created using graphite pencil, colour pencils, acrylic paint, black ink and cut paper. The colour pencil and ink lines were applied minimally, and the ink on the woman's jacket collar was applied wet-in-wet to create a soft, inky texture. I applied the lines and marks loosely so the woman appeared less static – applying media in this way means that mistakes are often made, which is why the Clone Stamp tool comes in particularly useful.

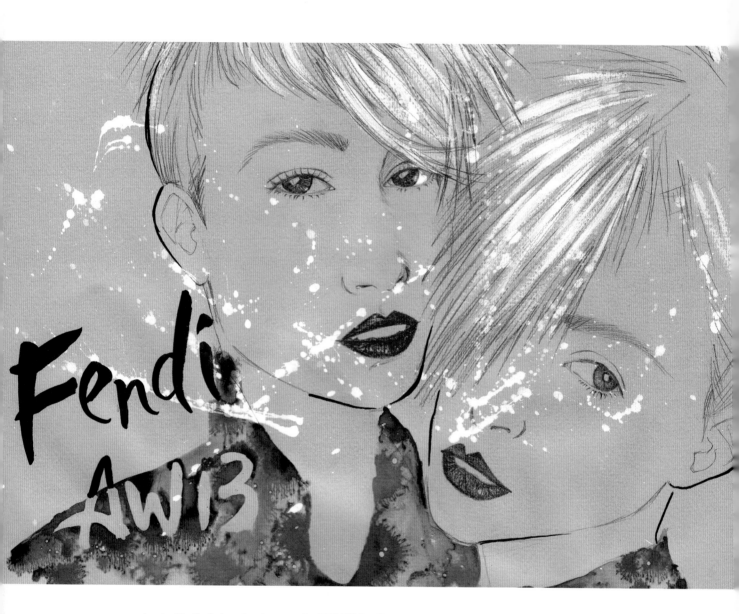

Inspired by the hair and make-up on the AW 2013 Fendi runway, this illustration was created with acrylic paint, graphite pencil, colour pencils, blue ink and masking fluid. I applied the masking fluid to the area where the letters overlap the woman's jacket, and to create areas of negative space. There were a few paint smudges and excess pencil lines that needed removing in this piece, for which I used the Clone Stamp tool.

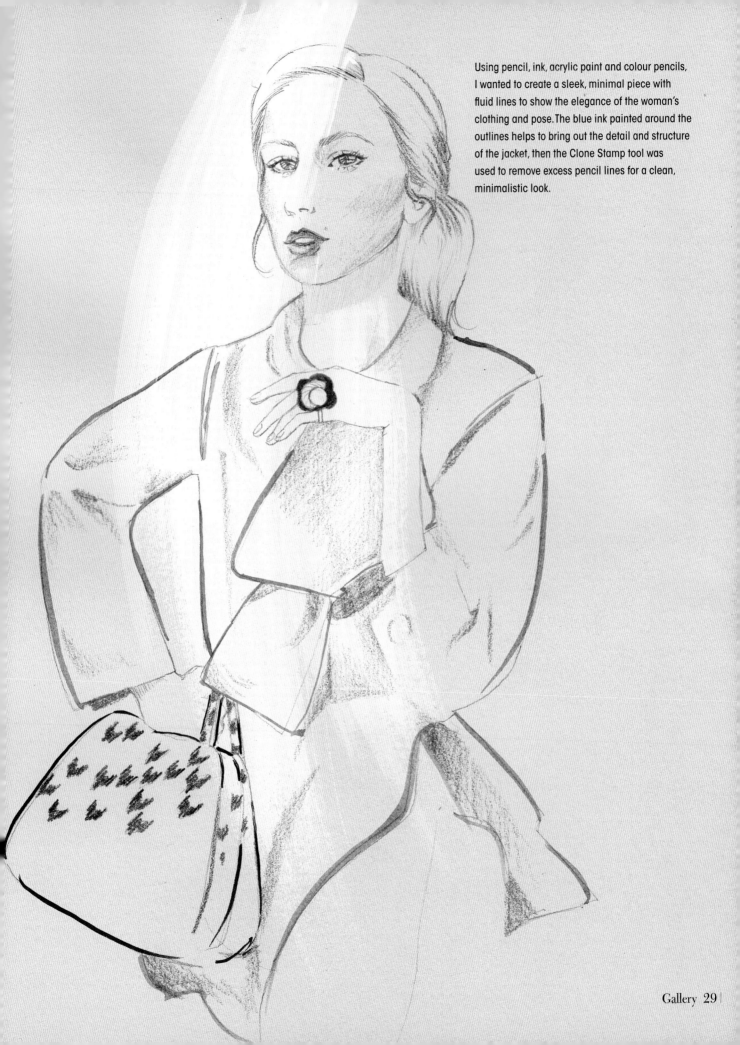

Using pencil, ink, acrylic paint and colour pencils, I wanted to create a sleek, minimal piece with fluid lines to show the elegance of the woman's clothing and pose. The blue ink painted around the outlines helps to bring out the detail and structure of the jacket, then the Clone Stamp tool was used to remove excess pencil lines for a clean, minimalistic look.

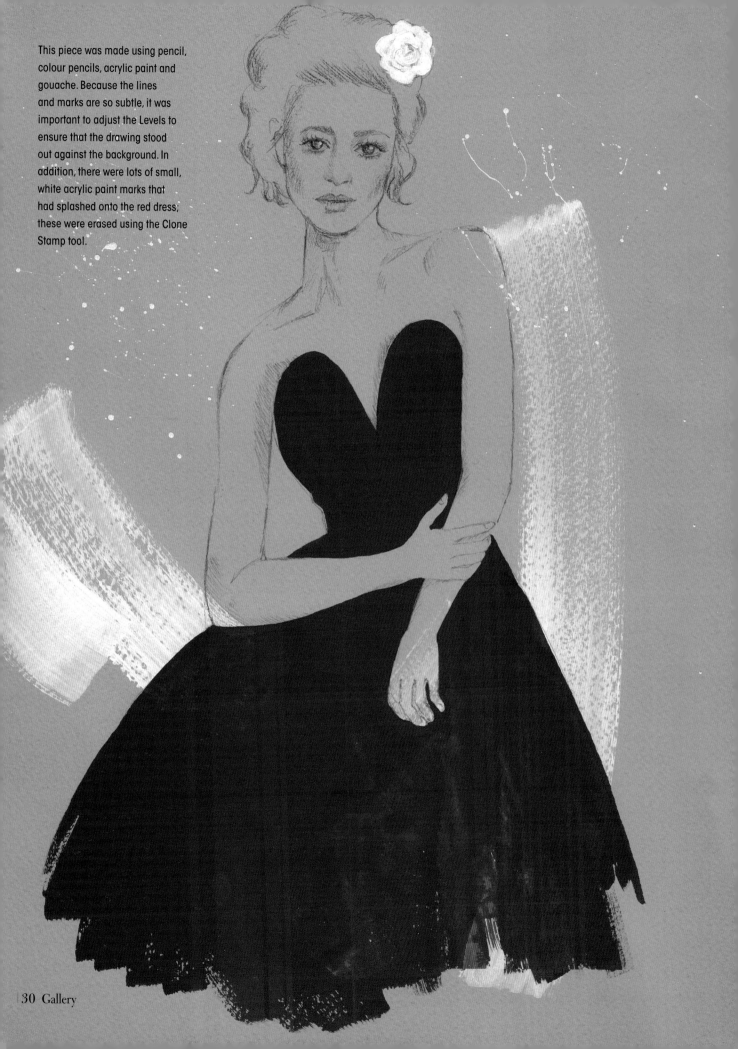

This piece was made using pencil, colour pencils, acrylic paint and gouache. Because the lines and marks are so subtle, it was important to adjust the Levels to ensure that the drawing stood out against the background. In addition, there were lots of small, white acrylic paint marks that had splashed onto the red dress; these were erased using the Clone Stamp tool.

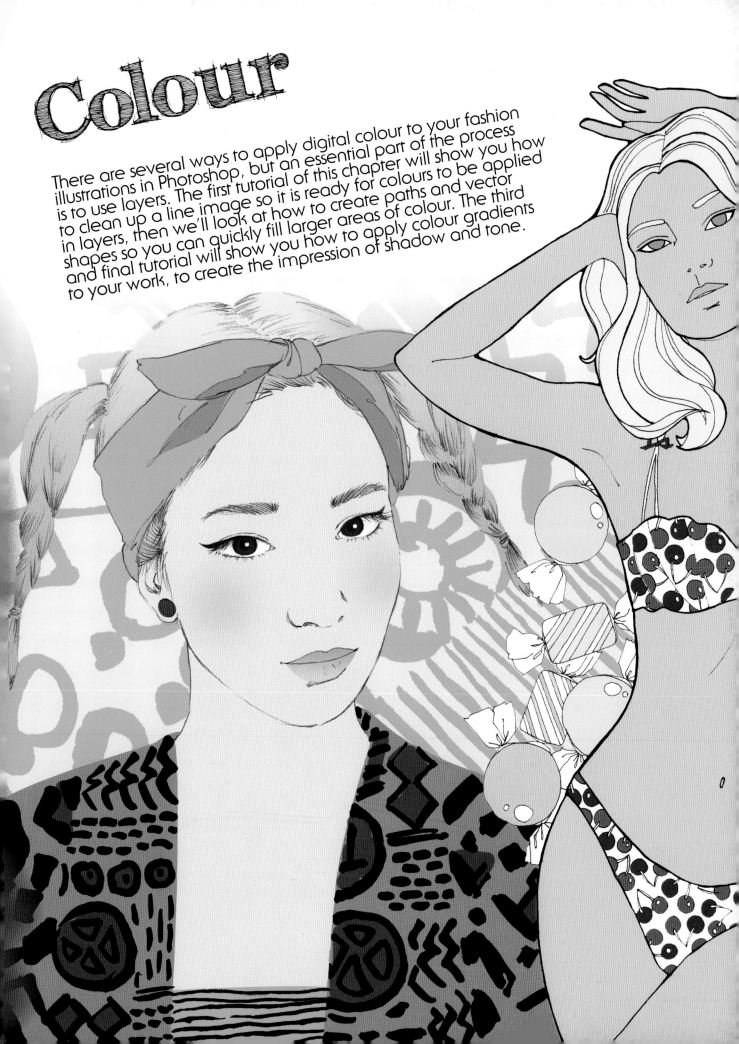

Colour

There are several ways to apply digital colour to your fashion illustrations in Photoshop, but an essential part of the process is to use layers. The first tutorial of this chapter will show you how to clean up a line image so it is ready for colours to be applied in layers, then we'll look at how to create paths and vector shapes so you can quickly fill larger areas of colour. The third and final tutorial will show you how to apply colour gradients to your work, to create the impression of shadow and tone.

CREATE LAYERS TO APPLY COLOURS
WITH THE BRUSH TOOL

To prepare a scanned line drawing for adding colours in layers, we first need to remove the white background so the only visible part is the black outline of the artwork – this is a process used repeatedly throughout this book. Then the colours are applied in separate layers using the Brush tool. Adding colours in layers means that if there are mistakes, or the colours don't look quite right, we can easily remove individual colour layers without affecting the rest of the artwork.

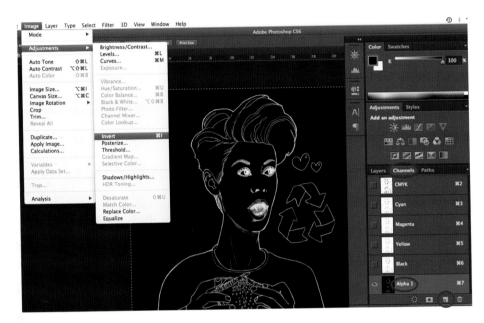

Open your scanned line drawing in Photoshop. This particular drawing was created with quite a bold outline, so did not need the intensity of line adjusted to make it stand out. However if you think your line drawing is too faint, go to Image > Adjustments > Levels and adjust the dial on the histogram to increase the line intensity.

Now choose Select > All and then Edit > Copy. Click on the Channels palette, then the small square icon at the bottom to create a new channel. This will make your canvas go completely black, and you will see a new channel added to the list named Alpha 1. Go to Edit > Paste in order to paste the drawing into a new channel layer then select Image > Adjustments > Invert, and you will see that the image colours have been inverted. The black areas of the work are now masked out so they are protected and isolated from editing, whereas the white areas of the line drawing are the only parts that are now editable.

When you scan an image for this process, you may also want to use the Eraser tool to clean up blemishes and dust (see Scan, clean and retouch a freehand illustration).

Now return to the Layers palette, and create a new layer by clicking on the small, square New Layer icon in the Layers Tool palette. Go to Select > Load Selection then select Alpha 1 from the Channel drop-down option in the dialogue box. This will make your selection (the white outline you created in your alpha channel layer) appear in a new layer, so you can fill the area with black in the next step.

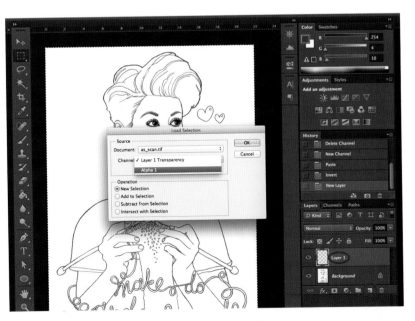

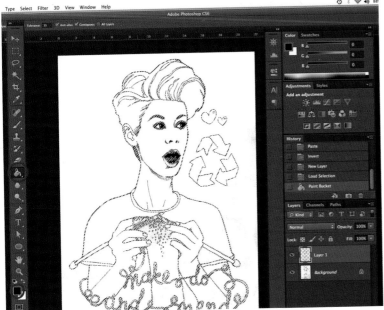

You will now see a new selection in the form of a dotted line around your line drawing. Choose the Foreground Color icon then select black from the colour picker. Select the Paint Bucket tool to click on your canvas and fill your selection with black. You will now see your line drawing filled with black, separated from your background. You may choose a different colour as an outline, if you wish.

As a shortcut to deselect a selection, use Control D on a PC, or Command D on a Mac.

Now go to Select > Deselect and drag the Background Layer into the Trash icon to delete it, as it is no longer needed . You see that Layer 1 is now the only layer visible: its chequered grey and white background means that this area contains no colour at all – the only colour visible should be the black outline. In other words, you have removed the white background of your line drawing, so you can fill the remaining space with colours of your choice. Before colouring, double click on Layer 1 to rename it as 'drawing', so you know it is the line drawing part of your work. Go to the Channels palette then drag the Alpha 1 layer into the Trash icon to delete it, as it is also no longer needed for your artwork. At this stage I always find it easier to work by creating a new layer, naming it 'background' and filling it with white using the Paint Bucket tool. This makes your image much clearer, as the chequered white and grey squares can be a little distracting.

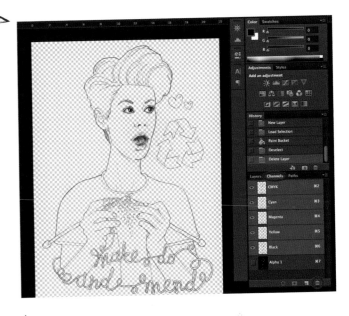

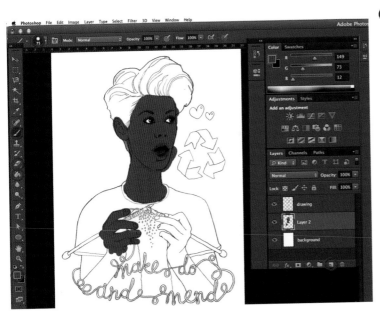

Click on the small, square New Layer icon at the bottom of the Layers palette, then drag this new layer beneath the 'drawing' layer; this means that the black outline will always sit on top of the layers of colour. Select the Brush tool then your choice of colour by clicking on the Foreground Color icon, and adjust the size and hardness of the brush. Click the brush on your canvas to apply colour; you can use the Eraser tool to remove colour that is not inside the lines in the same way. Just make sure you create a new layer for each colour you apply with the Brush tool, so you can edit or remove individual colours if needed. Once all elements of the illustration are coloured, use the Paint Bucket tool to fill the Background Layer, ensuring it is dragged to the very bottom of the Layers palette, as shown.

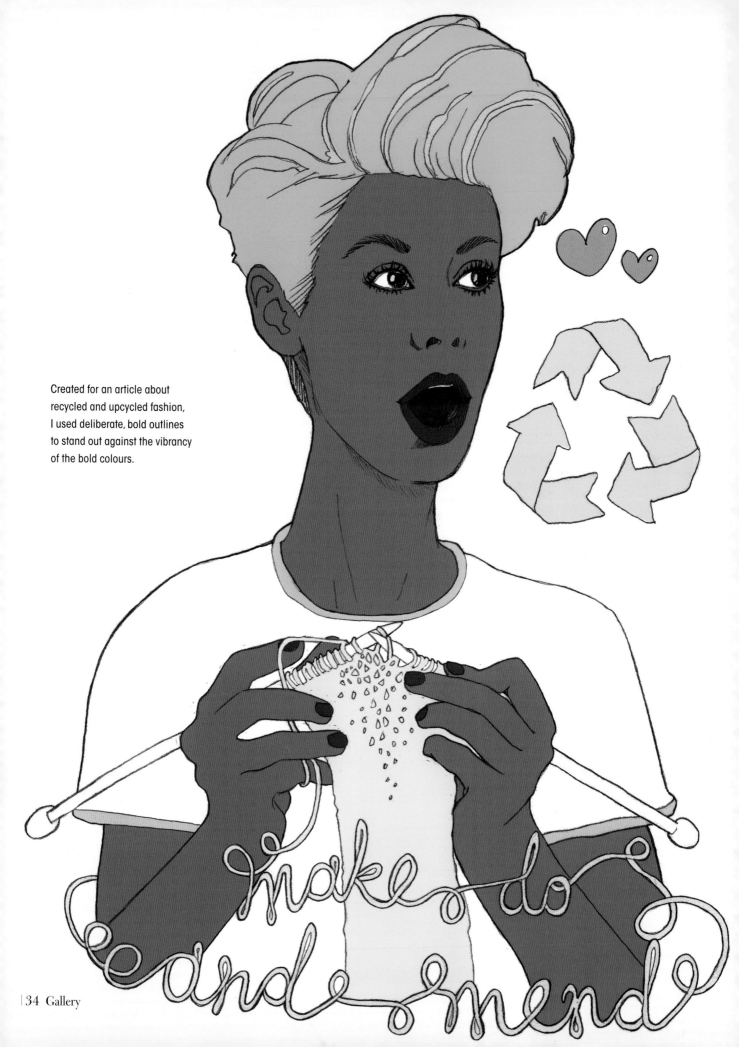

Created for an article about recycled and upcycled fashion, I used deliberate, bold outlines to stand out against the vibrancy of the bold colours.

make do and mend

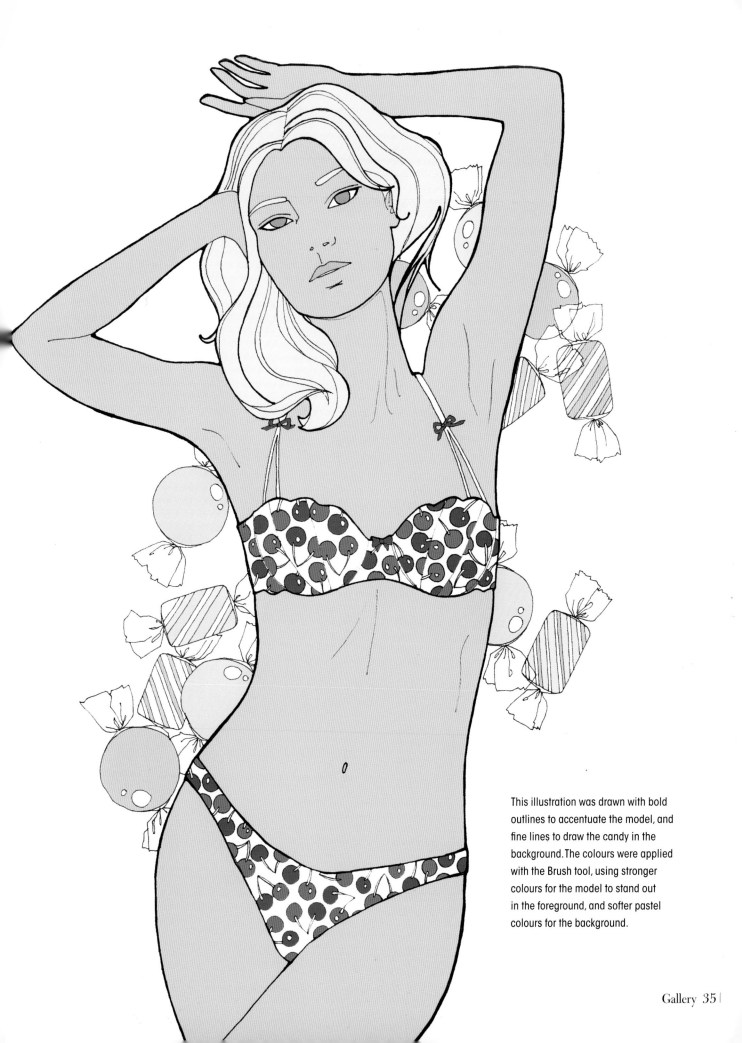

This illustration was drawn with bold
outlines to accentuate the model, and
fine lines to draw the candy in the
background. The colours were applied
with the Brush tool, using stronger
colours for the model to stand out
in the foreground, and softer pastel
colours for the background.

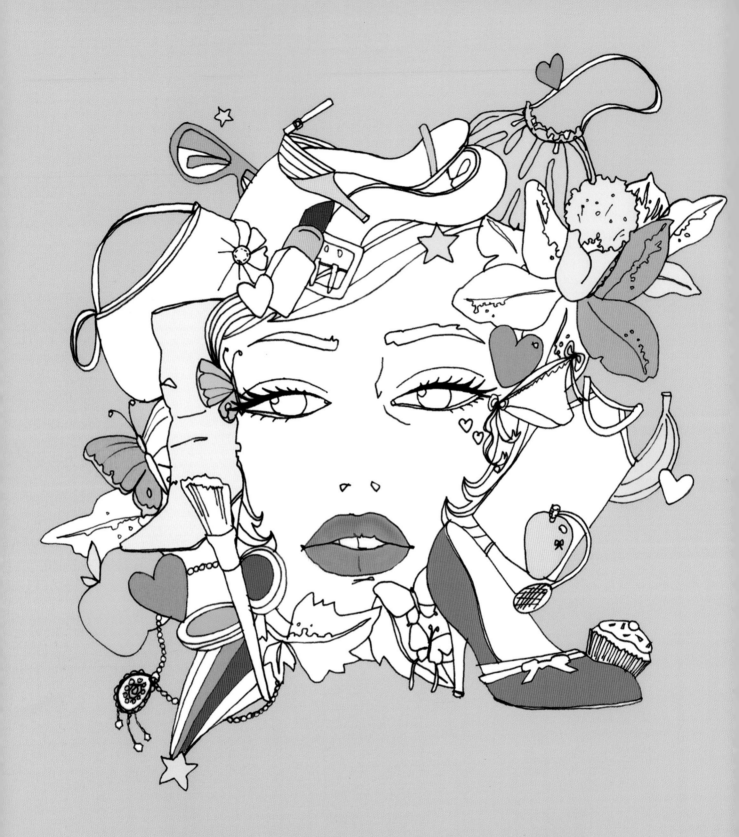

This illustrates a girl's world – all the things that young, fashionable women love and long for. It was drawn with a fine liner pen to create strong shapes and outlines, and flat colour was applied in areas to add accents. The background colour was applied with the Paint Bucket tool, while areas of the illustration were left white to balance the negative space with the colour and composition.

CREATE A PATH WITH THE PEN TOOL
TO ADD COLOUR

This tutorial will show you how to create a path or outline in Photoshop using the Pen tool, which can then be filled with colour. The benefits of using the Pen tool rather than the Brush tool is that you can create sections of colour more precisely, and edit colours and shapes in a wider variety of ways. It does require practice to become used to working with the Pen tool, so I recommend practising on a blank canvas to get used to the way in which this tool works.

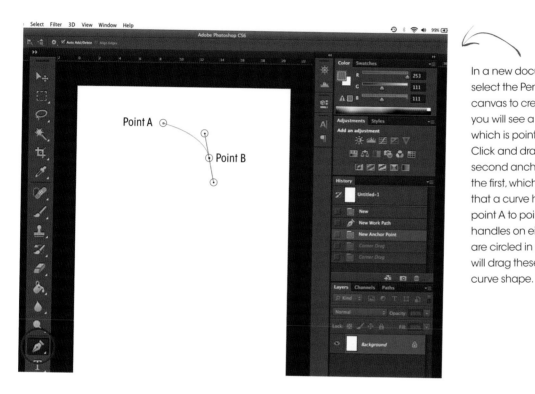

In a new document in Photoshop, select the Pen tool then click on the canvas to create your first anchor point; you will see a tiny square dot appear, which is point A in the screen grab. Click and drag your cursor to create a second anchor point not too far from the first, which is point B. You will now see that a curve has been created, from point A to point B; you will also see two handles on either side of point B, which are circled in red. In the next step, you will drag these handles to adjust the curve shape.

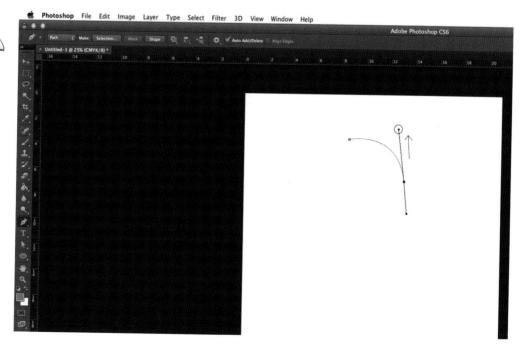

To distort the curve, hold down the Alt key and drag one of the handles. In this image, both handles were adjusted so the arch of the curve was more acute. To change the actual placement of an anchor point, hold down the Command key on a Mac, or the Control key on a PC.

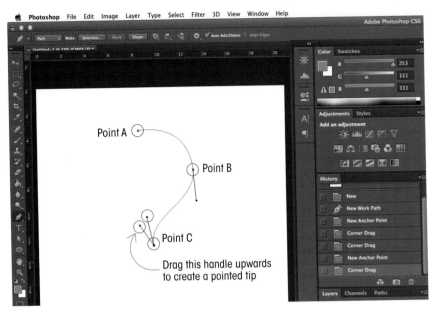

Point A

Point B

Point C

Drag this handle upwards
to create a pointed tip

Now click below point B to create a third anchor point C, then drag the point a little wider to create an S-shaped curve. I then wanted to change the direction of the curve so I dragged the handle upwards in the direction of the arrow to create the pointed tip of the teardrop shape, and to change the direction of the path. Add a fourth anchor point halfway between point C and A, and then a fifth to re-join with point A to complete the shape. You will see a small '0' appear as you join your final anchor point back to the first.

You can make new path layers in the same way as you create layers, by clicking on the small square icon at the bottom of the Paths palette. This allows you to go back and change the shape or colours of a path if you want to, or easily delete it by dragging it into the Trash.

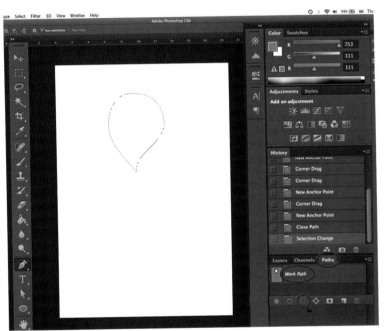

With the path completed, go to the Paths palette where you will find your path layer. Click on the dotted circle icon at the bottom of the palette, which will turn your path into a selection.

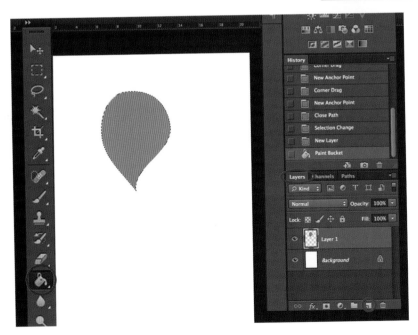

Now go to the Layers palette, and create a new layer by clicking on the square New Layer icon at the bottom of the palette. Select the Paint Bucket tool, and fill the selection with colour. Go to Select > Deselect to deselect the shape.

COLOUR A FULL ILLUSTRATION
USING PATHS

Once you feel more confident using the Pen tool to create paths you can try this process, which makes adding colour faster and more precise than using the Brush tool alone. In this tutorial, we use the Pen tool to create anchor points that follow the shapes and outlines within an illustration, then fill these with colour using the Paint Bucket tool.

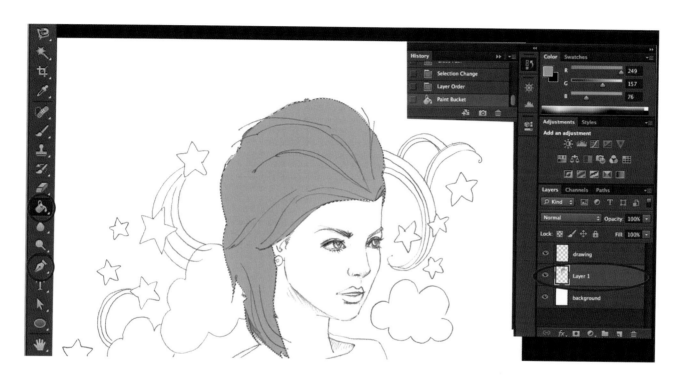

Open your scanned line drawing in Photoshop, and prepare the image so it is ready for layers of colour to be added (see Create layers to apply colours with the Brush tool). You can see here that I have created an additional Background Layer and filled it with white colour using the Paint Bucket tool. Rename the line drawing layer as 'drawing', and the Background Layer as 'background'.

Now start to create paths with the Pen tool, adding anchor points that follow the direction of the curves in the model's hair. Where your final anchor point meets the first anchor point you will see a small '0' icon, indicating that your path is complete. Go to the Paths palette where you will see the path layer, then click on the dotted circle icon at the bottom of the palette to turn your path into a selection. Create a new layer, and fill the selection with colour using the Paint Bucket tool. Repeat this step to fill the model's face with a skin colour.

Tip

When applying a path to follow curves, space your anchor points further apart for flatter curves, and closer together for more acute ones.

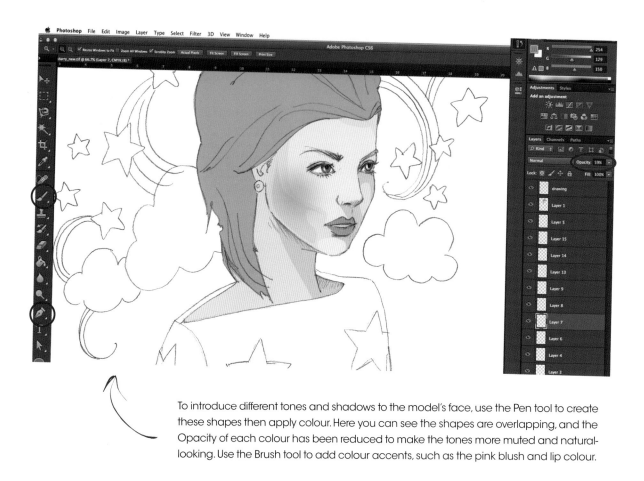

To introduce different tones and shadows to the model's face, use the Pen tool to create these shapes then apply colour. Here you can see the shapes are overlapping, and the Opacity of each colour has been reduced to make the tones more muted and natural-looking. Use the Brush tool to add colour accents, such as the pink blush and lip colour.

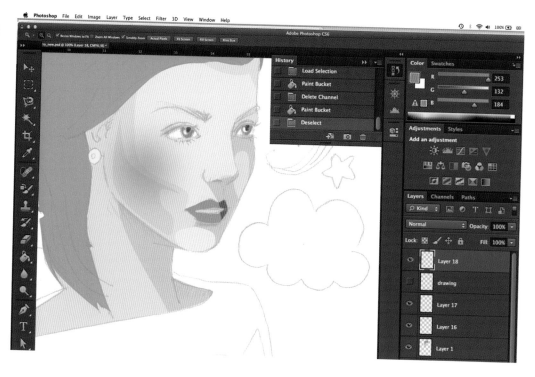

I decided to make the background pattern pink. To do this, select the drawing layer then click on the white background with the Magic Wand tool. Right click and choose Select > Similar then Select > Inverse; a dotted line will appear around the black outline of your drawing, meaning that this area has been selected. Create a new layer, then fill this with a pink colour using the Paint Bucket tool.

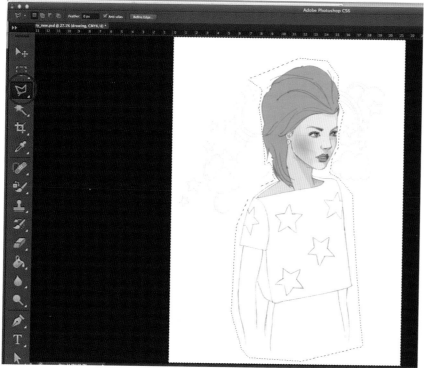

For this step, I want to remove the pink outline from the model so she is outlined in black, but keep the pink outline for the background pattern area. To do this, select the Polygonic Lasso tool then click points close the outline of the model to create a loose selection, which separates her outline and the pattern behind. Once the selection has been made, hit Delete to remove the pink outline from the model. Right click, select Inverse, then choose the drawing layer. Hit Delete again to erase the black from the background, leaving only the pink outline visible.

When applying colours, always make sure that each new colour is created in a new layer, and that each new path is created in a new path layer. This makes it much easier if you want to go back and edit or remove particular parts of the work.

Use the Pen tool and Paint Bucket tool to add further sections of colour to the model's clothes, making sure each colour is created in a new layer. Next use the Pen tool to draw around the points of one of the stars on the model's top to make it into a selection then fill with the Paint Bucket tool.

Use the Marquee tool to drag a box around the star, go to Edit > Copy, then paste this selection into a new layer. You can then select Image > Adjustments > Transform to adjust or rotate the shape to apply it to the remaining stars.

Use the Brush tool to apply colour to the background elements, and to complete the image use the Paint Bucket tool to fill the Background Layer with a pastel blue colour.

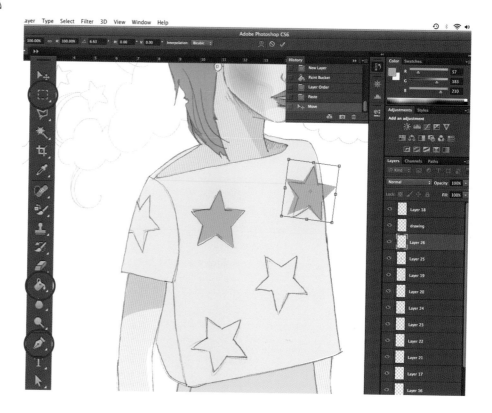

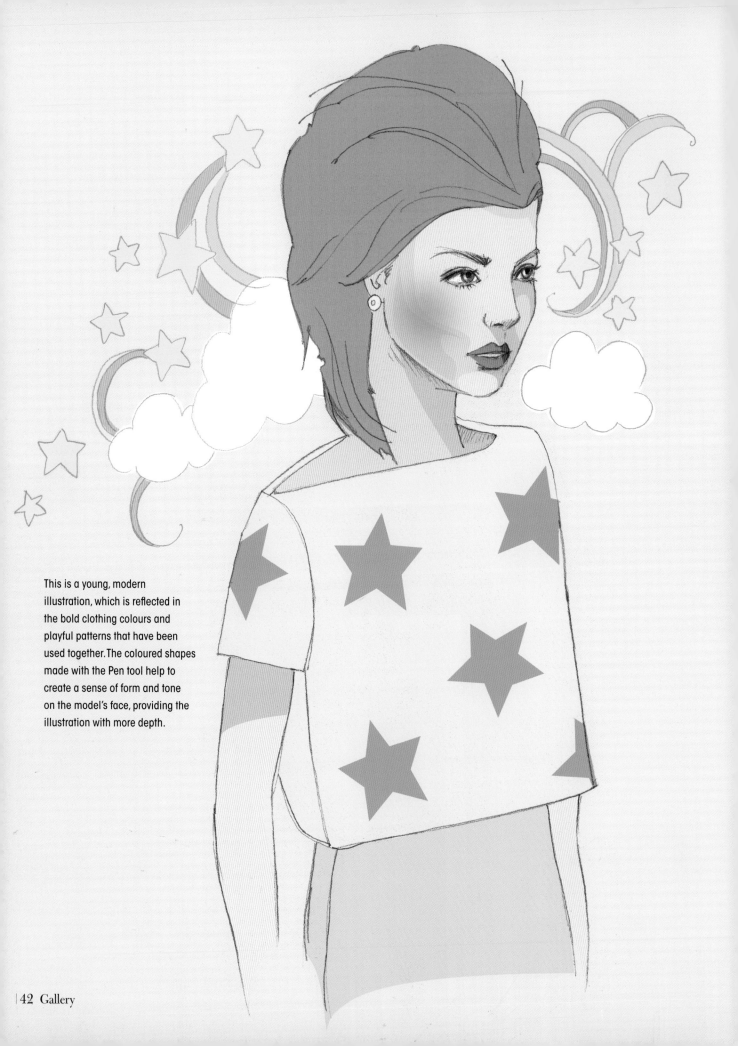

This is a young, modern illustration, which is reflected in the bold clothing colours and playful patterns that have been used together. The coloured shapes made with the Pen tool help to create a sense of form and tone on the model's face, providing the illustration with more depth.

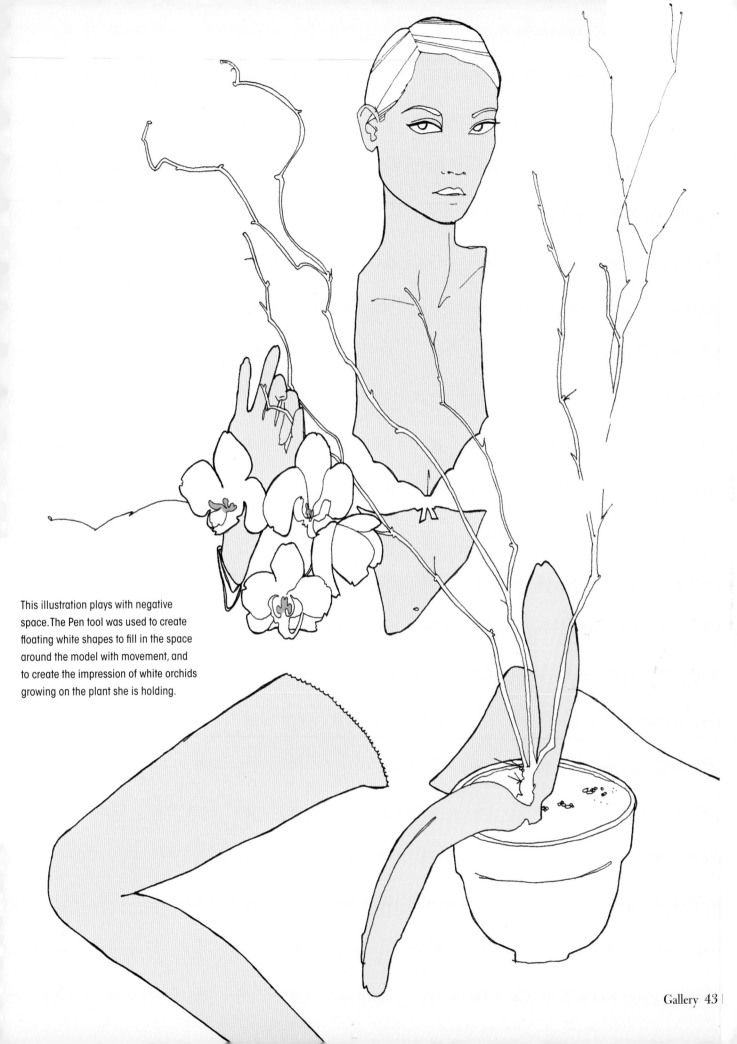

This illustration plays with negative space. The Pen tool was used to create floating white shapes to fill in the space around the model with movement, and to create the impression of white orchids growing on the plant she is holding.

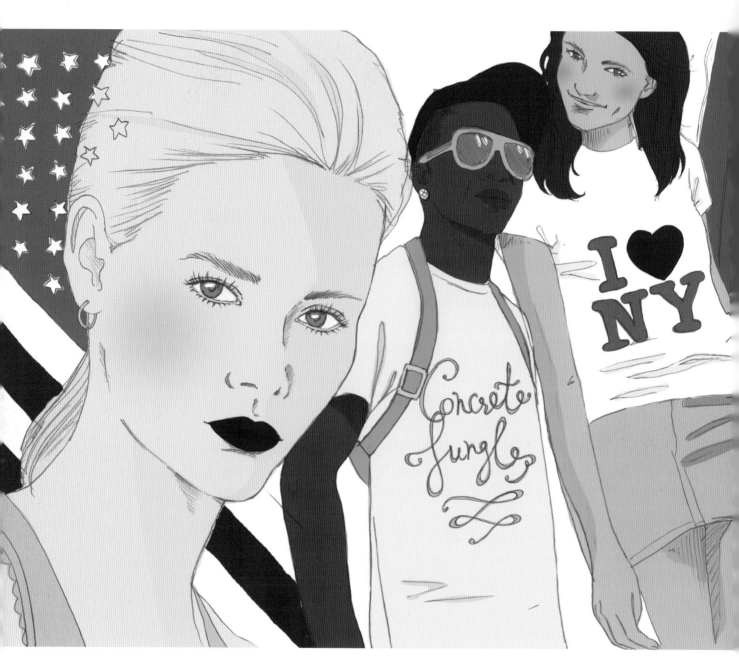

This image illustrates the youth, culture and fashion of New York City with bold colours. The Pen tool was used to create colour shapes for the shadows on the people's faces, while the Brush tool was used to add looser, sketchier colours to some of the background scene.

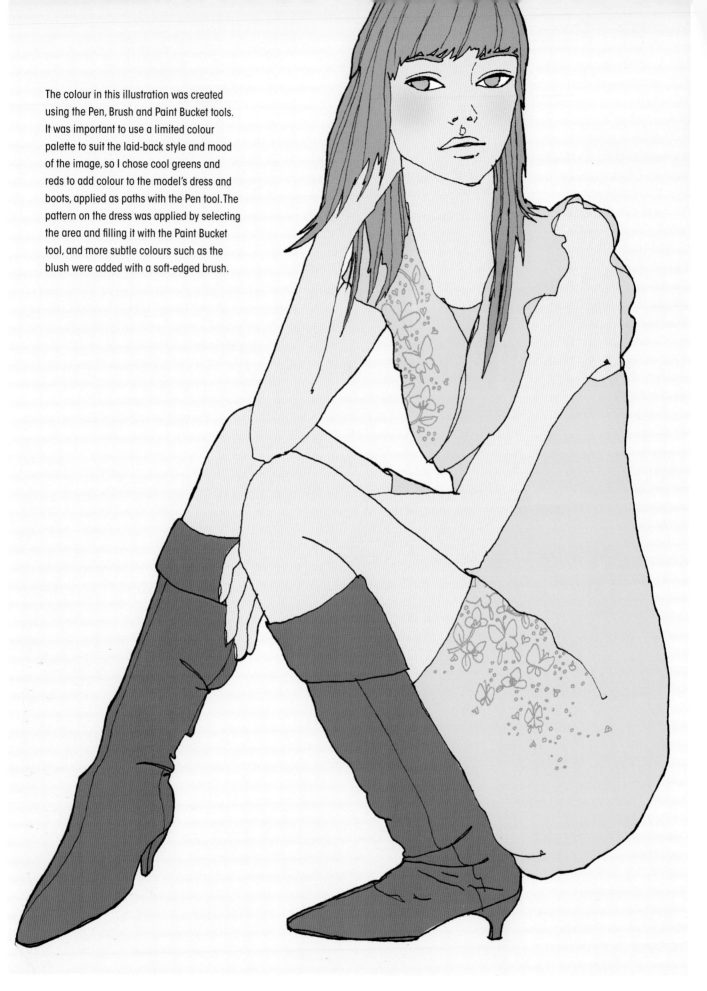

The colour in this illustration was created using the Pen, Brush and Paint Bucket tools. It was important to use a limited colour palette to suit the laid-back style and mood of the image, so I chose cool greens and reds to add colour to the model's dress and boots, applied as paths with the Pen tool. The pattern on the dress was applied by selecting the area and filling it with the Paint Bucket tool, and more subtle colours such as the blush were added with a soft-edged brush.

CREATE AND APPLY
COLOUR GRADIENTS

Colour gradients can provide an image with depth by creating tones and shadows, or a wider range of colour shades. This tutorial will show you how to apply these gradients to a beauty illustration, which will produce a sense of tonal depth that would not be achievable if created with flat colours.

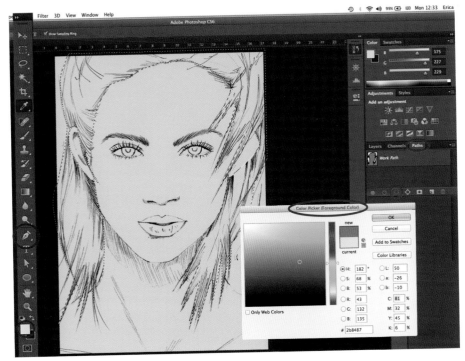

Open your scanned drawing in Photoshop, and prepare the image so it is ready to be coloured (see Create layers to apply colours with the Brush tool). Here I have filled my background with a bright blue, and I plan to base my colour scheme around this colour. Using the Pen tool, draw around the shape of the hair. Once the path is complete, go to the Paths palette and click on the dotted circle icon to make it into a selection. Now click on the Foreground Color icon, and choose a shade of blue darker than the background colour from the Color Picker dialogue box.

Create a new layer by clicking the small square New Layer icon at the bottom of the Layers palette. Now click and hold the Paint Bucket tool to select the Gradient tool; you can see that it is the icon with a black and white gradient across it. Make sure that Foreground to Transparent is chosen from the drop-down options at the top of the workspace, then click a point at the bottom of the canvas, roughly central to the inner edges of the model's hair, and drag upwards to create a vertical line reaching about two-thirds of the way up the canvas. This line indicates the start and end point of your gradient.

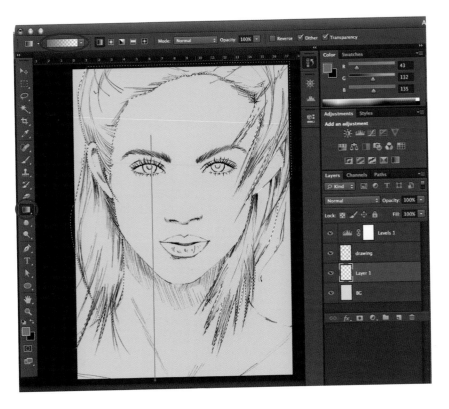

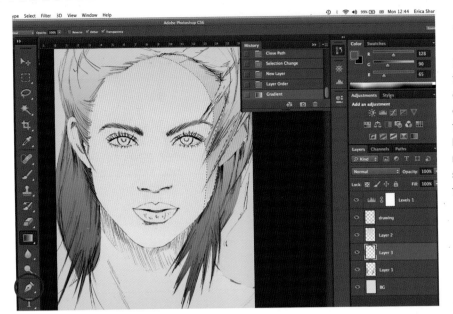

Now use the Pen tool to draw around the model's face and neck. Here the gradient has been applied in the same way as in the previous step, although the gradient begins from the top of the canvas rather than the bottom. Using the Pen tool, I have also drawn a curved path on the right-hand side of the model's face and filled this section with a darker coloured gradient, to create the impression of a shadow.

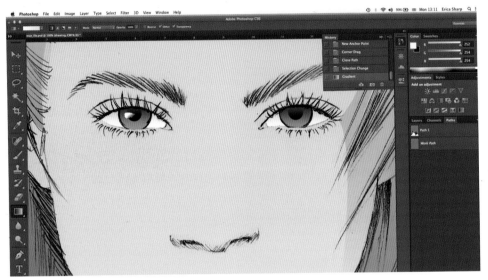

To start adding finer details to the model's face, draw around the irises with the Pen tool then add flat colour with the Paint Bucket tool. In a new layer, apply a gradient over the top using a darker shade of blue for the shadows. Create the centres of the pupils by selecting the Ellipse tool, holding down Shift, then dragging to create a circle that fits the pupils. Go to the Paths palette and select the small dotted circle icon to make this circle into a selection then fill it with a dark grey. With the Pen tool, create small, pear-shaped reflections on the surface of the eye then fill these with a white gradient.

In the same way that you add colour to your canvas in separate layers, ensure that gradients are created in new layers too, so they are easily removable if unsuccessful.

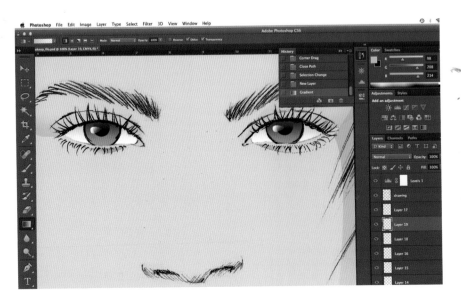

Now with the Pen tool, create curved shapes above and below the model's eyes. Fill these areas with blue gradients, starting from the edge of the eye and moving outwards. The same technique was applied to the lips: a dark pink gradient was applied starting from the centre of the mouth to the outer edges. Use the Brush tool with a soft-edged brush setting to create blush on the model's cheeks.

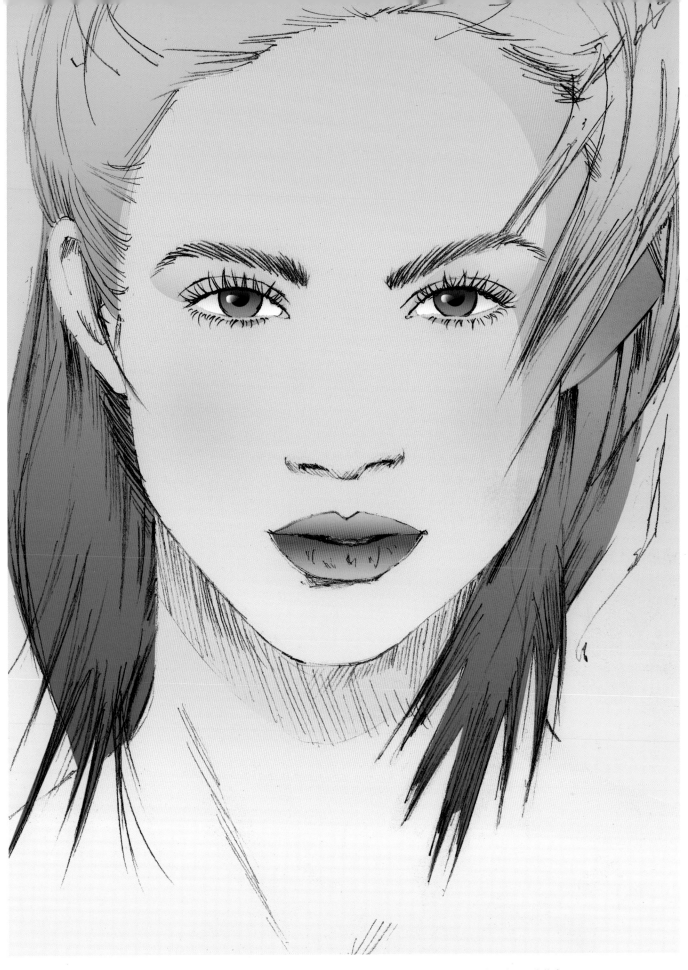

Through the application of paths and gradients with the Pen tool, subtle shadows and tones have been created on the model's face.

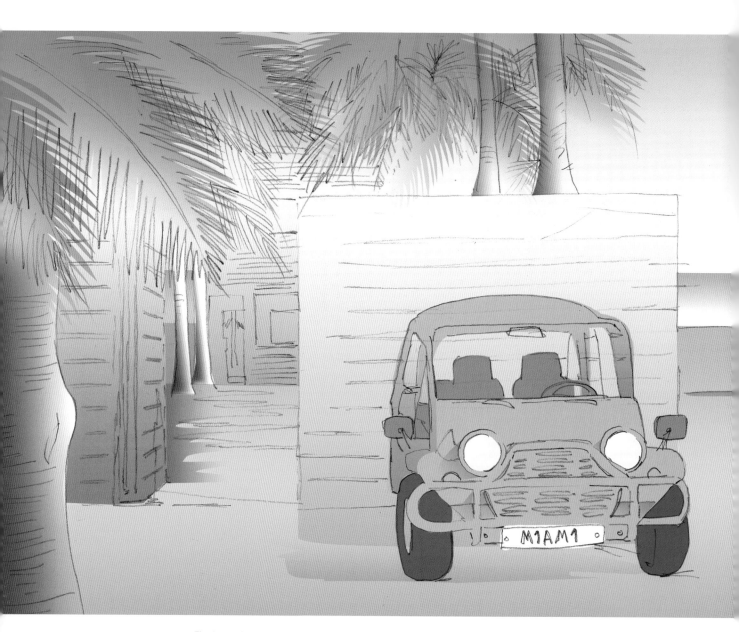

The heat of a tropical summer is conveyed through the vibrant tropical colours
used here. The Gradient tool was used to help create a sense of light and shadow,
and warm sunshine shining down on the models and the beach.

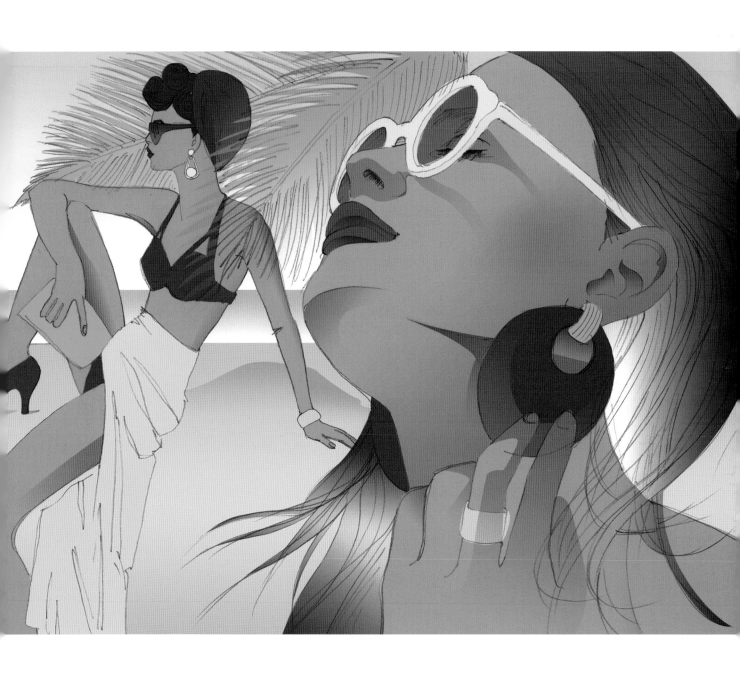

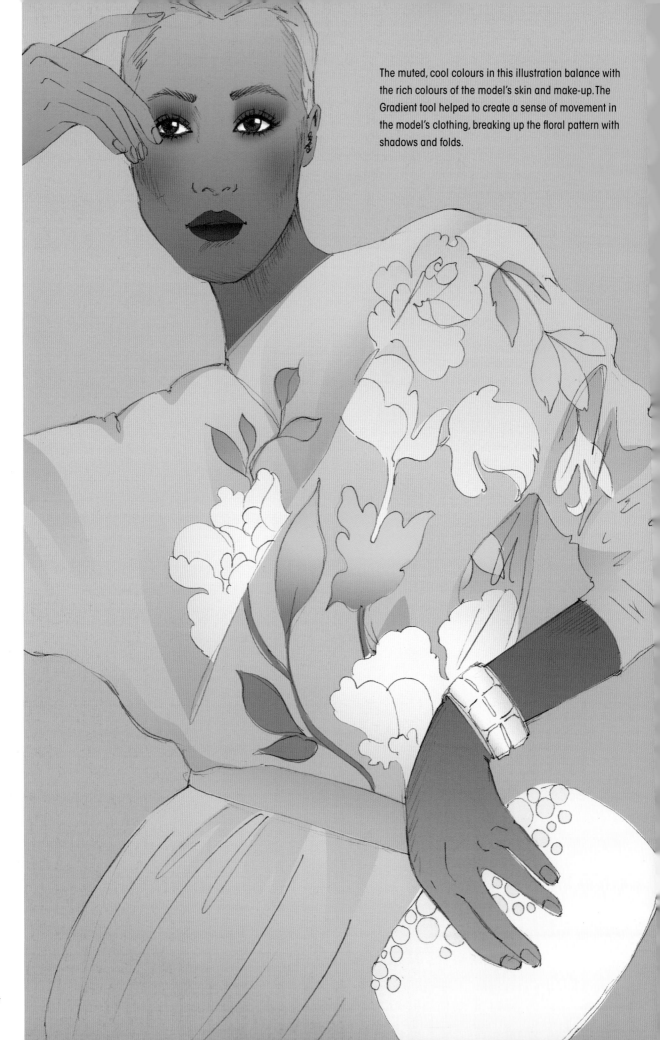

The muted, cool colours in this illustration balance with the rich colours of the model's skin and make-up. The Gradient tool helped to create a sense of movement in the model's clothing, breaking up the floral pattern with shadows and folds.

CREATE COLOUR SCHEMES
USING ADOBE KULER

Adobe Kuler allows you to create and save colour schemes based on various colour rules, then apply them to your illustrations in Photoshop. As well as being an incredibly useful and powerful resource, Adobe Kuler is also free – simply visit https://kuler.adobe.com to set up your own online account.

Once you have set up an account and loaded Adobe Kuler, go to the Create option at the top of the screen. You will see a colour wheel with dials around it, and a list of colour rules on the left-hand side of the screen. The dial with the small arrow inside is your main colour dial, and by dragging it around the colour wheel the other dials will adjust automatically, based on the colour rule you have selected. At the same time, your colour scheme will be visible in the five swatches underneath the colour wheel. Once you are happy with a colour scheme, click Save; you will have the option of naming your colour scheme, which will be saved into My Themes.

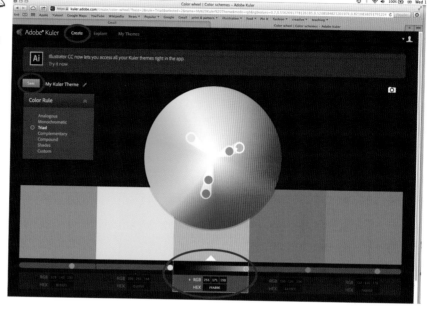

Always save the colour schemes you create in Adobe Kuler; you may want to use the same colour scheme or colour rule more than once, or perhaps make subtle changes to an existing colour scheme.

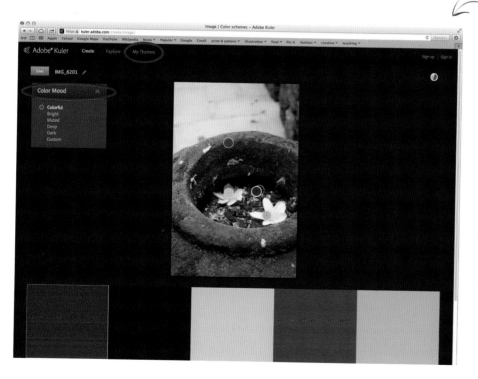

Another fantastic function of Adobe Kuler is the ability to upload a photo or an existing image, and to create new colour schemes based on this. Here I have uploaded one of my holiday photographs because I liked the combination of bright and earthy colours. Click on the camera icon on the right-hand side of the colour wheel; this allows you to upload a photo of your choice. You can then choose Colour Mood options on the left-hand side of the screen and Adobe Kuler will automatically create a colour scheme for you, based on these colour moods. Alternatively you can create a custom colour scheme by picking sections of the photograph yourself. Save your colour schemes into My Themes.

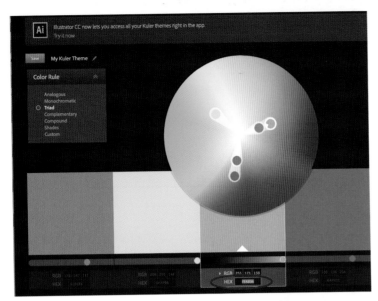

To apply your colour schemes to your illustrations note the Hex Values, which are unique codes that translate as specific colours in Adobe programs. To view the Hex Values of a colour scheme, go to My Themes and choose the Edit option. The colour scheme will appear below the colour wheel, and the Hex Value is visible beneath each colour, as shown. Highlight this code and select Copy.

With your illustration open in Photoshop, click on the Foreground Color icon then paste the Hex Value into the # box in the dialogue. Photoshop will automatically select the colour from your colour scheme, which you can then apply to your work as flat colours or gradients.

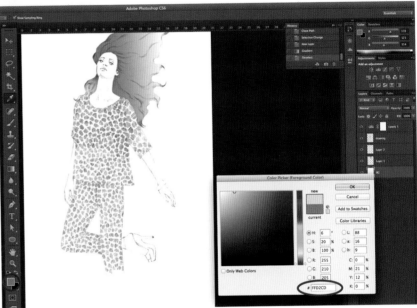

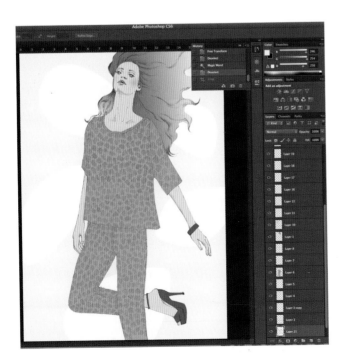

I collect my own photographs from my travels to create a colour board on Pinterest, which forms a collection of both my own and online-sourced photographs containing colours that inspire me.

For this particular illustration, I added an additional colour to my colour scheme for the bubble shapes in the background, as I felt the background needed breaking up a little to match the movement of the model in the foreground. I made these bubble shapes a shade lighter than the background colour itself, which provided enough movement in the background without distracting from the main subject.

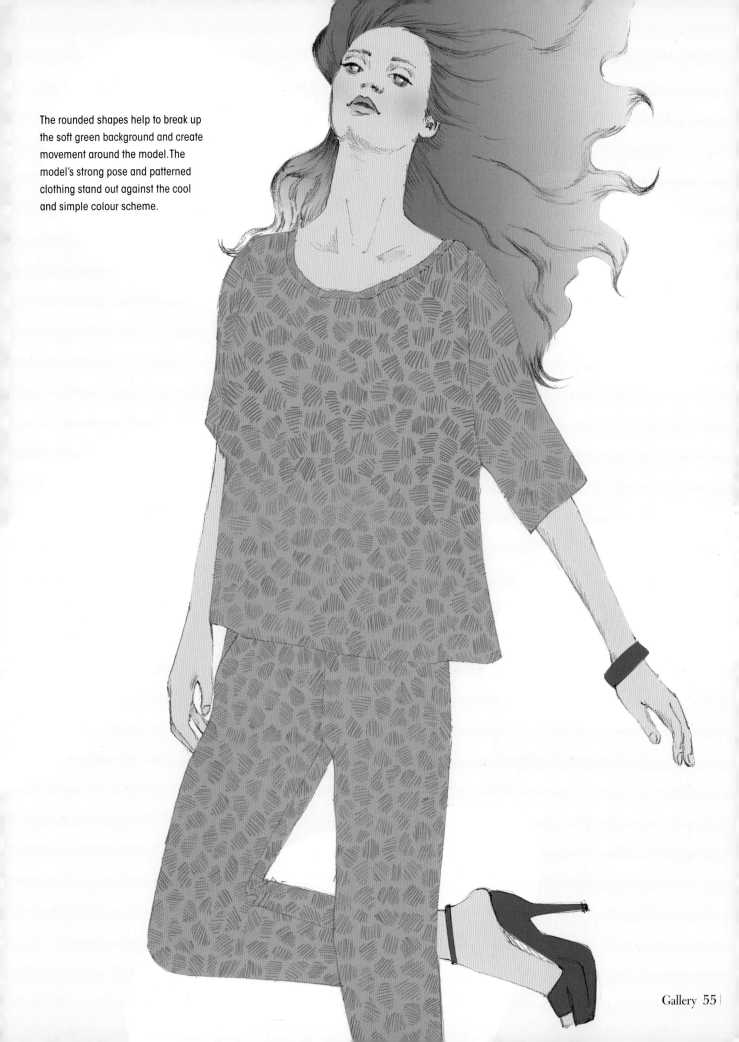

The rounded shapes help to break up the soft green background and create movement around the model. The model's strong pose and patterned clothing stand out against the cool and simple colour scheme.

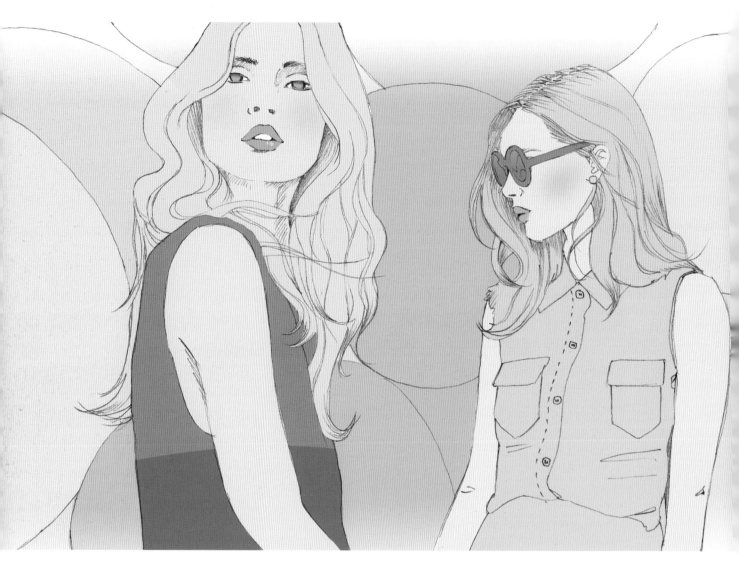

Filled with girls and balloons, this evokes a feminine mood. The faraway expressions and soft pastel colour schemes help create the sense of a romantic, dreamy narrative.

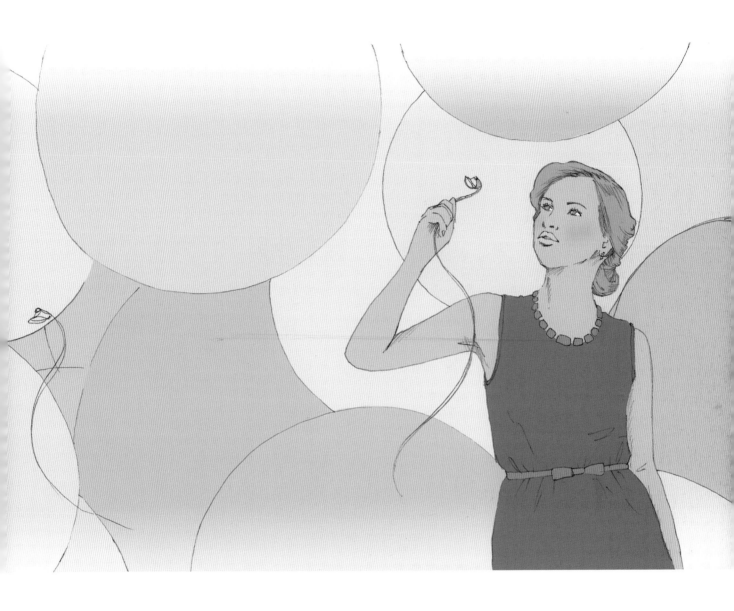

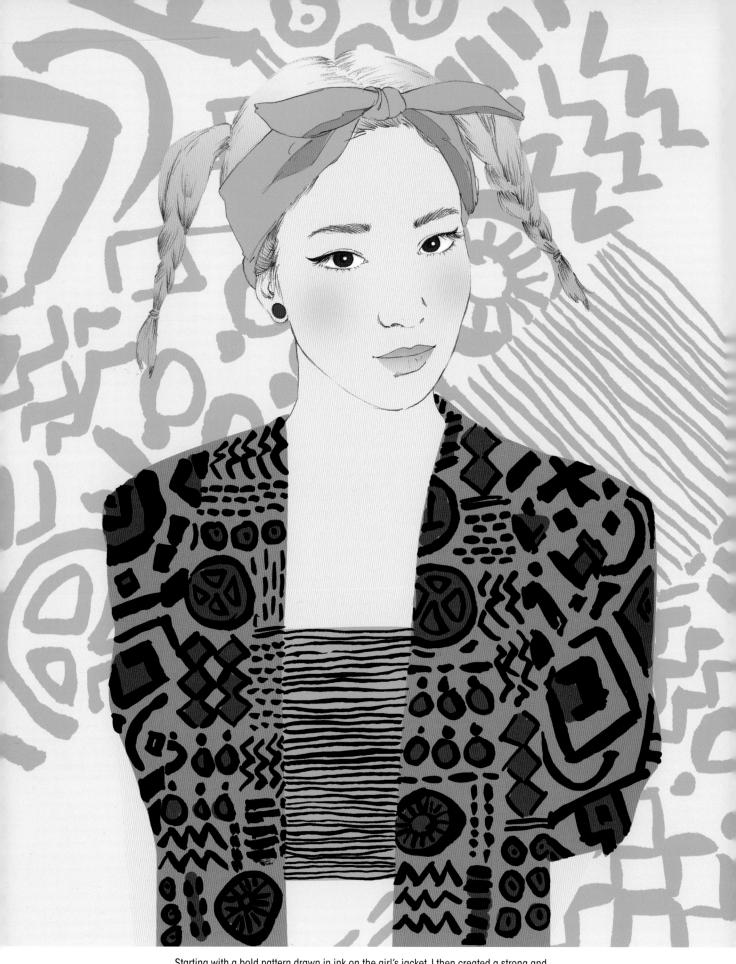

Starting with a bold pattern drawn in ink on the girl's jacket, I then created a strong and complementary colour scheme to fit this youthful and quirky fashion illustration.

Textures

Incorporating scanned or digital brushes and textures is an exciting way to add the quality of fabric to your work, or decorative elements to backgrounds. I have chosen to incorporate textured papers, fabrics and digital brushes to the illustrations in this chapter, to achieve a variety of interesting, experimental results.

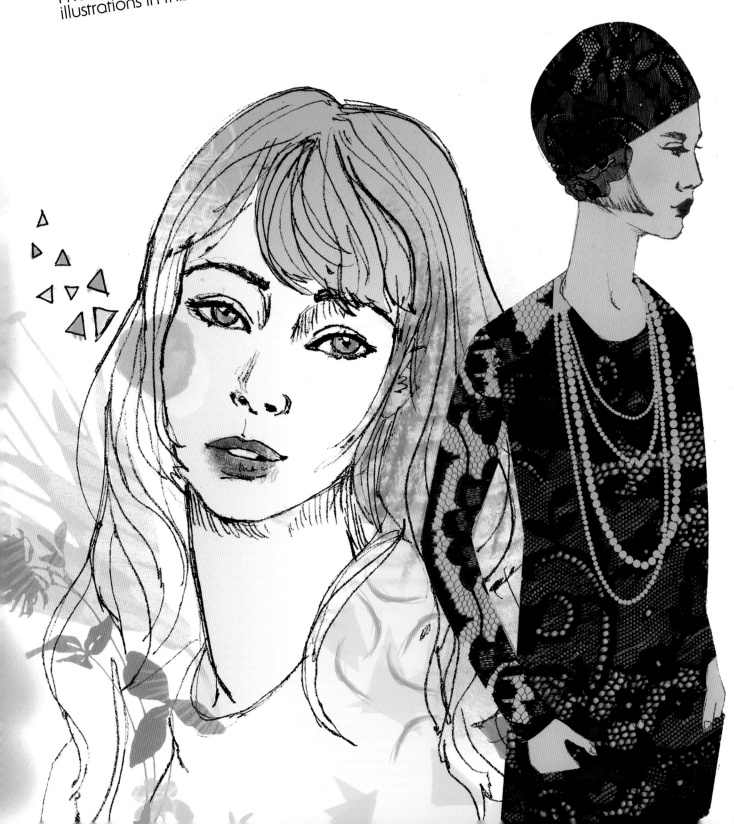

APPLY PAPER ELEMENTS
TO A DRAWING

Incorporating patterned or textured paper elements is an interesting and alternative way to incorporate colour into your work. It will add a more handcrafted look, which can work well when paired with more subtle digital colour accents. These pieces were drawn on lightly coloured, textured paper, chosen to work in harmony with the added textures and muted colours.

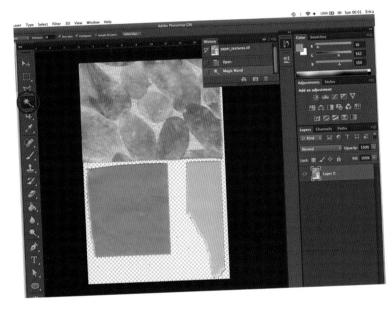

Scan the drawing you wish to work on, and adjust the Levels so the image looks as close to the original as possible (see Scan, clean and retouch a freehand illustration).

Now scan a variety of textured and coloured papers and open this document in Photoshop. Double click on the Background Layer in the Layers palette to open a new layer then click OK; this unlocks your layer so it is easy to edit. Using the Magic Wand tool, select the white background surrounding your scanned papers and hit Delete to remove any unwanted white areas. Save your paper scans as .psd files or uncompressed .tif files.

I collect paper for these kinds of projects from various sources including art stores, paper suppliers and vintage books.

Open your drawing in Photoshop. I wanted to fill the woman's dress with a texture that is quite natural and subtle, so I chose a handmade textured paper. Open your scanned paper and select an area you wish to use in your drawing using the Marquee tool, then choose Edit > Copy.

On the illustration use the Pen tool to draw around the curved sections of the woman's dress, clicking and dragging the points to create a path, as outlined earlier in the book (see Colour a full illustration using paths). When your path is closed, create a selection in the Paths palette and go to Edit > Paste Special > Paste Into. You can then use the Move tool to move the paper selection around to achieve your desired colour and texture.

I wanted the image to look quite minimal and elegant; I therefore chose to add subtle colour to the cheeks, lips, shades and hair. To do this, use the Brush tool to apply muted colour accents to the woman's face. Reduce the Opacity as desired to reveal the line drawing underneath, and to ensure the colour is not too heavy.

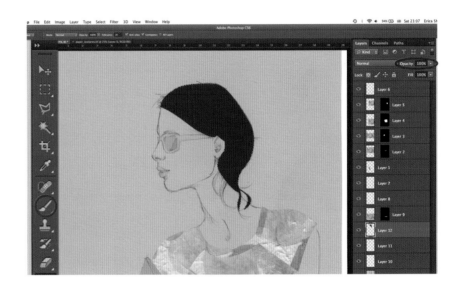

Tip

When working with colour, always make sure you create a new layer for each new colour you apply, so you can easily remove the ones that don't work successfully.

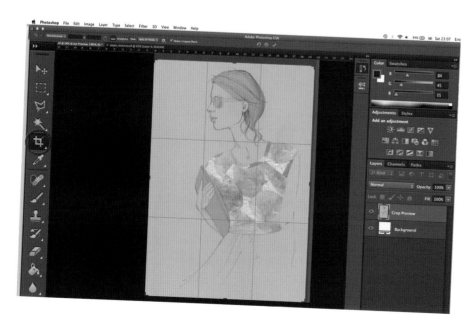

Finally, crop the image with the Crop tool (see Photograph, clean and retouch an artwork) to create your finished composition.

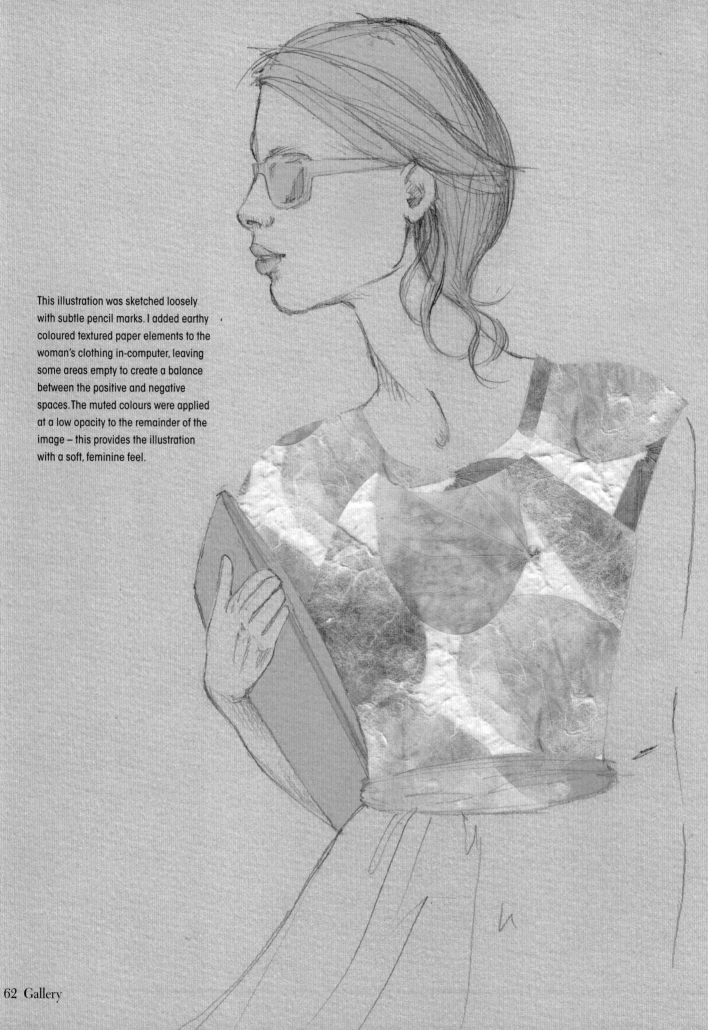

This illustration was sketched loosely with subtle pencil marks. I added earthy coloured textured paper elements to the woman's clothing in-computer, leaving some areas empty to create a balance between the positive and negative spaces. The muted colours were applied at a low opacity to the remainder of the image – this provides the illustration with a soft, feminine feel.

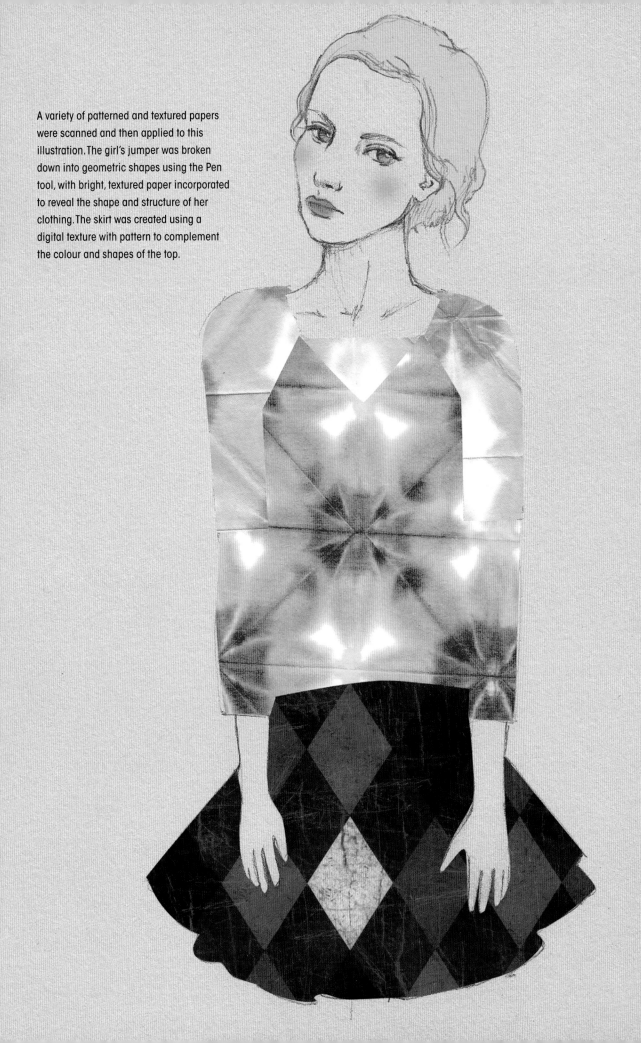

A variety of patterned and textured papers were scanned and then applied to this illustration. The girl's jumper was broken down into geometric shapes using the Pen tool, with bright, textured paper incorporated to reveal the shape and structure of her clothing. The skirt was created using a digital texture with pattern to complement the colour and shapes of the top.

APPLY FABRIC ELEMENTS
TO A DRAWING

Adding fabrics to the clothing in a fashion illustration can transform it with texture, layers and volume; fabric also helps to convey the cut, pattern and shape of the clothing type worn. I have roughly sketched the placement of the clothing in my illustrations first, as the basis for layers of scanned fabric elements and shapes, and to emulate the shape and structure of the clothing effectively.

Scan your drawing, clean it up (see Scan, clean and retouch a freehand illustration) and prepare the image so it is ready to be coloured (see Create layers to apply colours with the Brush tool). In the drawing used in this tutorial there are some loosely sketched areas that I want to fill with fabrics – don't worry that these look a little messy, as they will be erased later.

Now scan a variety of fabrics; I find that detailed and textured fabrics, such as lace, work well. Open one of your scanned fabric documents in Photoshop, and double click on the Background Layer in your Layers palette. A new layer window will appear – click OK to unlock this, making it easy to edit. Use the Magic Wand tool to select the white background. In this case the lace has holes that expose the white area, which you want to remove. Right click, select Similar, and hit Delete to remove these unwanted white areas; then save as a .psd or uncompressed .tif file.

Tip

Always save your fabric scans as .psd files, or uncompressed .tif files.

I scanned an end page from an old book, because I felt the texture and colour would work well as a background for this vintage-inspired illustration. Open the scanned paper in Photoshop, go to Select > All, and copy and paste it into a new layer in your scanned drawing document, ensuring this layer is dragged to the bottom of the document's Layers palette. Go to Image > Transform > Scale to resize the paper to fit inside the canvas area.

Open your adjusted scanned fabric in Photoshop then select an area of the fabric with the Marquee tool and choose Edit > Copy. Open your scanned drawing, and use the Pen tool to draw around the curved shapes of the woman's hat and clothing; you will need to click and drag the points to create a path (see Colour a full illustration using paths). When your path is closed, create a selection in the Paths palette and go to Edit > Paste Special > Paste Into.

Lace works well as a texture in vintage-inspired illustrations, as seen in the finished art throughout this chapter.

My lace section looked too large initially, so I chose Edit > Transform > Scale to shrink it down, hitting the Enter key when the scale looked appropriate. If you are resizing this way, always make sure you hold down the Shift key when dragging the corners to help constrain the proportions.

Repeat this step for the main section of the woman's dress. Again, use Edit > Transform to resize or rotate the copied and pasted lace embellishments. I thought it would be interesting to play with the negative space in this illustration to create the impression of a long pearl necklace. To do this, select the layer containing the main part of the dress, and reduce the Opacity to around 50%, which in this case enabled me to see the positional lines I had sketched for the necklace. Follow these lines with the Eraser tool, using a hard-edged round brush setting and a variety of different sizes, to create the impression of beads. Once complete, increase the Opacity back to 100%.

Use the Brush tool to add colour to the face, creating a new layer for each new colour you apply. Select the line drawing layer and use the Eraser tool to remove any scruffy lines around the model's dress and necklace. In this instance, I cropped the image slightly when the illustration was complete to adjust the composition.

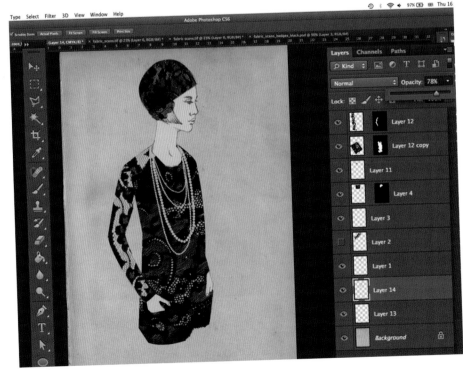

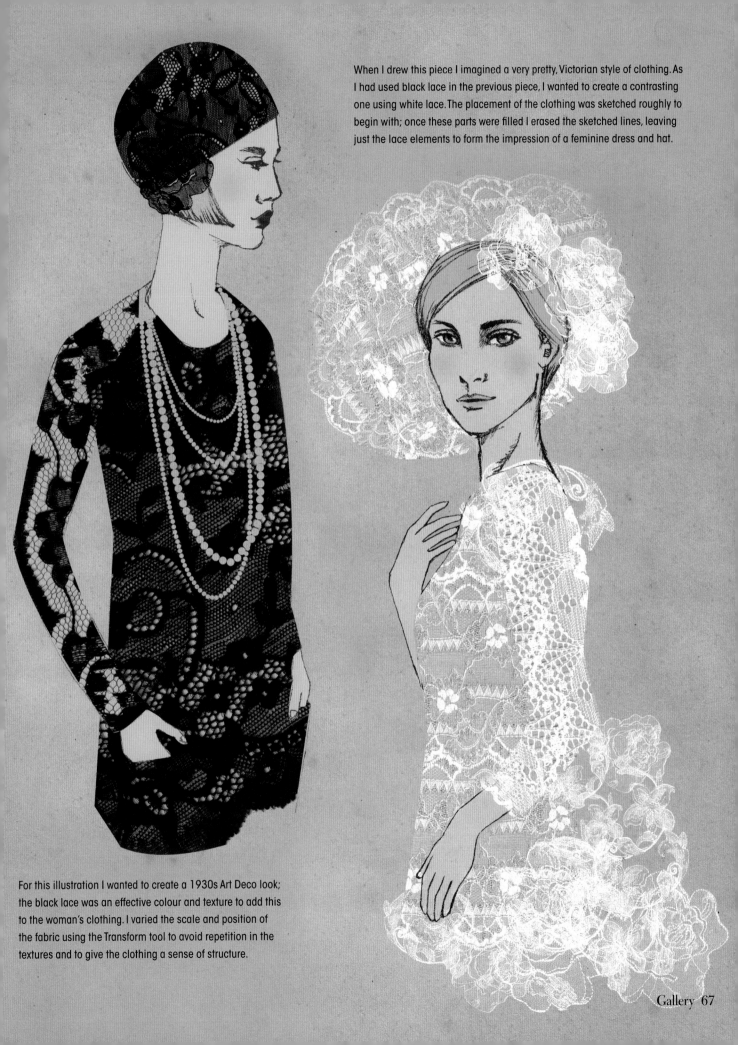

When I drew this piece I imagined a very pretty, Victorian style of clothing. As I had used black lace in the previous piece, I wanted to create a contrasting one using white lace. The placement of the clothing was sketched roughly to begin with; once these parts were filled I erased the sketched lines, leaving just the lace elements to form the impression of a feminine dress and hat.

For this illustration I wanted to create a 1930s Art Deco look; the black lace was an effective colour and texture to add this to the woman's clothing. I varied the scale and position of the fabric using the Transform tool to avoid repetition in the textures and to give the clothing a sense of structure.

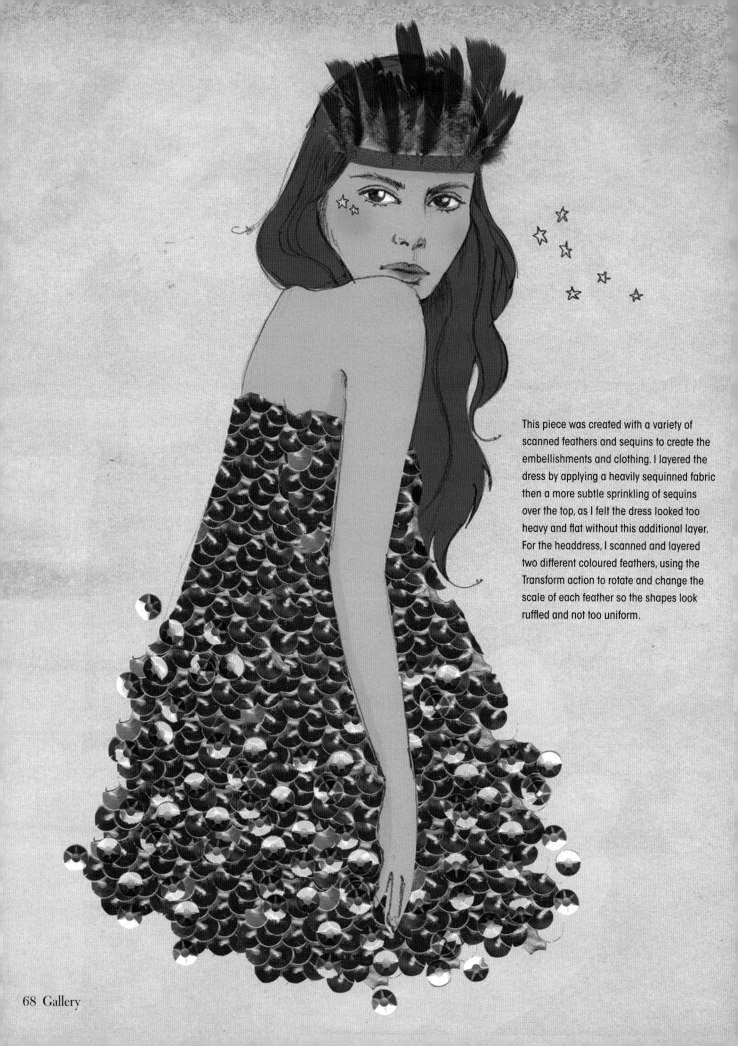

This piece was created with a variety of scanned feathers and sequins to create the embellishments and clothing. I layered the dress by applying a heavily sequinned fabric then a more subtle sprinkling of sequins over the top, as I felt the dress looked too heavy and flat without this additional layer. For the headdress, I scanned and layered two different coloured feathers, using the Transform action to rotate and change the scale of each feather so the shapes look ruffled and not too uniform.

USE DIGITAL BRUSHES AND TEXTURES
TO EMBELLISH A DRAWING

There is an abundance of digital brushes and textures that can be found online and used for commercial work. Search on the web then download your chosen brushes to your computer; they should upload automatically to your Brush palette in Photoshop. Textures are usually downloadable as high-resolution .jpg files, which you can copy and paste into your work.

Scan your drawing, clean it up, and prepare the image so it is ready to be coloured (see Create layers to apply colours with the Brush tool). Using the Pen tool, trace around the section of your illustration that you want to fill with textured brush and colour effects. I want my illustration to be fun and bold; in this instance I selected the woman's hair and dress so I can add bright layers of textured colour to these selections.

Once you have traced around the shape with the Pen tool, close the path and create a selection in the Paths palette. Select a textured brush, resize the brush so it is large enough to fill your selection, and fill the selected area with colour. I have started with a darker red, and will later layer a lighter red on top.

Tip

On the web you will find many paid-for digital brushes and textures to choose from, but ensure that you pay the license fee for commercial work if it is required. You can obtain free brushes and textures too; but again, ensure you check that there is permission to use them for commercial work.

Use a hard-edged brush to add colour to the woman's skin. Then use the Pen tool to select the shape of the woman's dress, and fill this selection with several layers of blue inky brush strokes. Always make sure you create a new layer for each new colour, so you can easily remove layers of colour that don't work as successfully. Continue to add further colour accents to the woman's face and accessories.

Think about what types of colours and textures will work in the background. This is quite a young, modern illustration, so I chose to add loose colour pencil textures to the background. Select a colour pencil texture you like from the Brush palette and resize, so it fills the background. Working in separate layers for each colour, use Edit > Transform > Rotate, along with the Move tool, to ensure the placement of the background texture works with the overall layout.

I didn't think that the bubbles I drew around the woman's head fitted with the overall illustration, so I erased them with the Eraser tool and decided to replace them with an alternative decorative element. Hold down the Ellipse tool, and select the Polygon tool from the Sub-tools palette. At the top of the workspace, choose the No Fill and No Stroke options, which are the boxes with a red strike through. In the Sides option choose six then drag the Polygon tool to draw a small hexagon. Go to the Paths palette, and click the dotted circle icon to create a selection. In a new layer, fill your selection with the Paint Bucket tool.

Copy and paste this layer several times, using the Move tool to arrange the shapes, and the Magic Wand and Paint Bucket tools to apply different colours. Select the shapes with your Magic Wand then use a textured brush to apply a texture over the top of the shapes. Once complete, crop the image if necessary, and save.

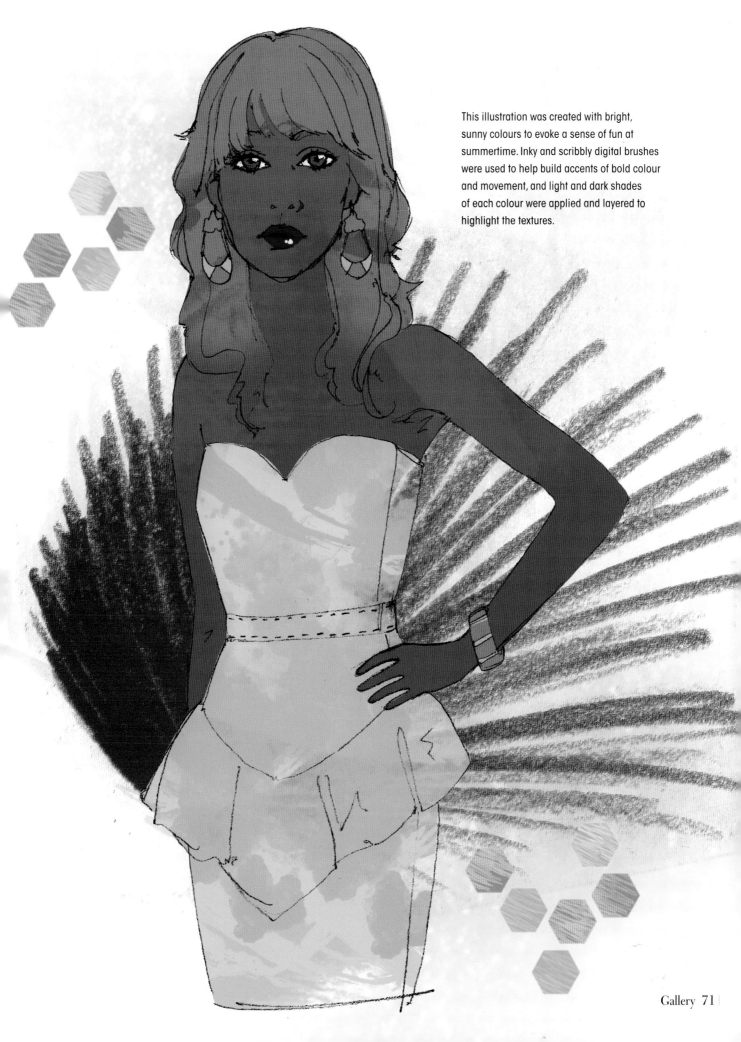

This illustration was created with bright, sunny colours to evoke a sense of fun at summertime. Inky and scribbly digital brushes were used to help build accents of bold colour and movement, and light and dark shades of each colour were applied and layered to highlight the textures.

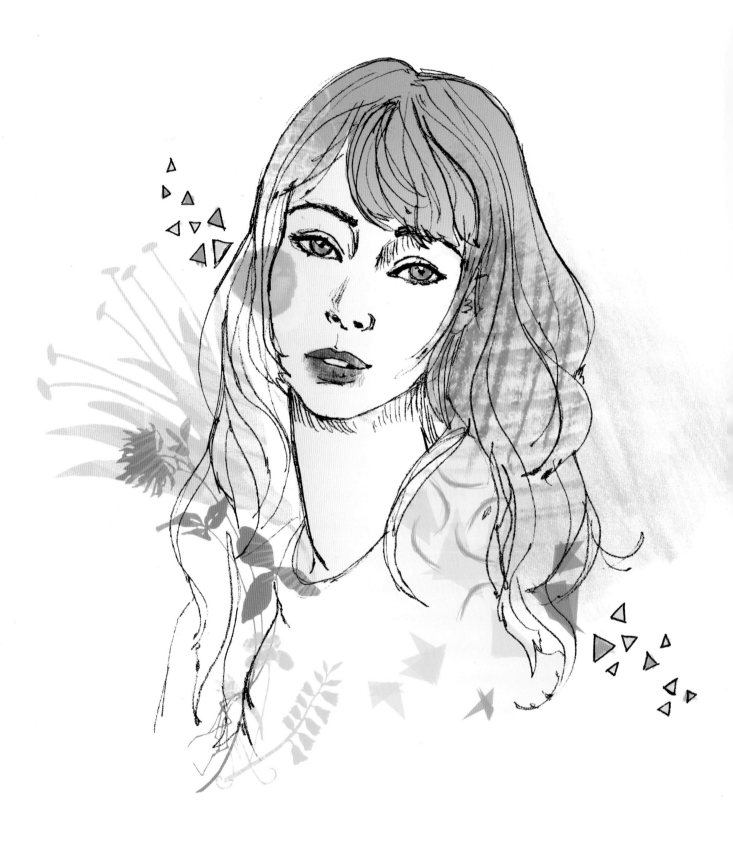

This piece was created with a romantic, summery feel. The drawing of the woman's face was quite simple, and I left space around it to fill with a variety of digital brushes. I used pastel colours to apply the floral brushes, arranged to frame the portrait, and combined these with soft pencil-mark brushes. Some parts, such as the large orange flower and the top of the woman's hair, were erased using the same brushes to break up the areas of flat colour.

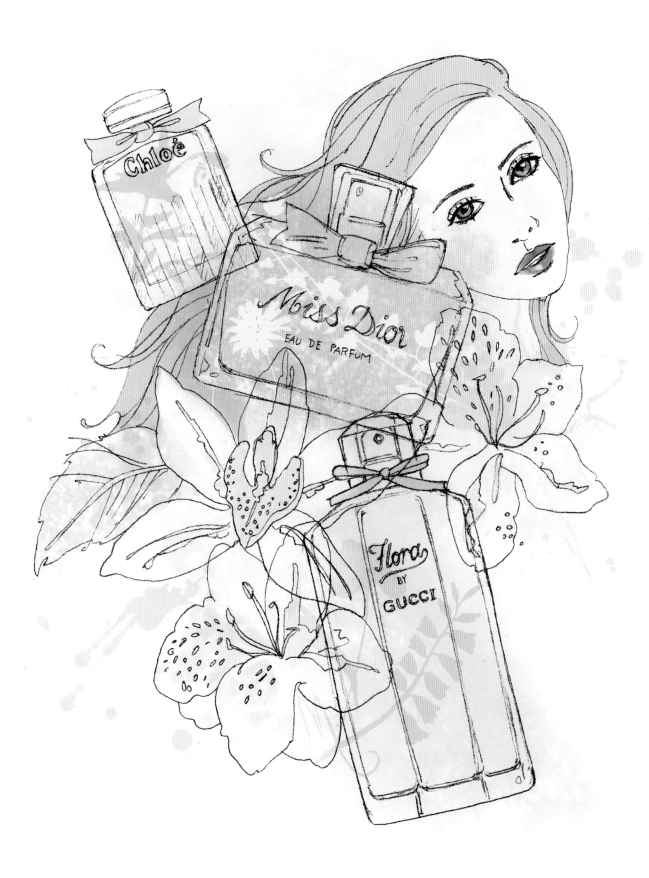

Soft textured brushes were used to add subtle colours to the background of this busy illustration.
Flowers were drawn amongst the perfume bottles to highlight the theme of perfume scents.
The digital brushes were overlaid onto the colour sections using both the Eraser and Brush tools
to create positive and negative spaces, and to suggest different types of scents for each perfume.

The woman and the flowers in this illustration were drawn with pencil and scanned. I then created several layers of the flowers in different colours to create a sense of a summery environment around the woman. The background was filled with soft watercolour brushes, and the pattern on the woman's dress was created with an arch-shaped textured brush.

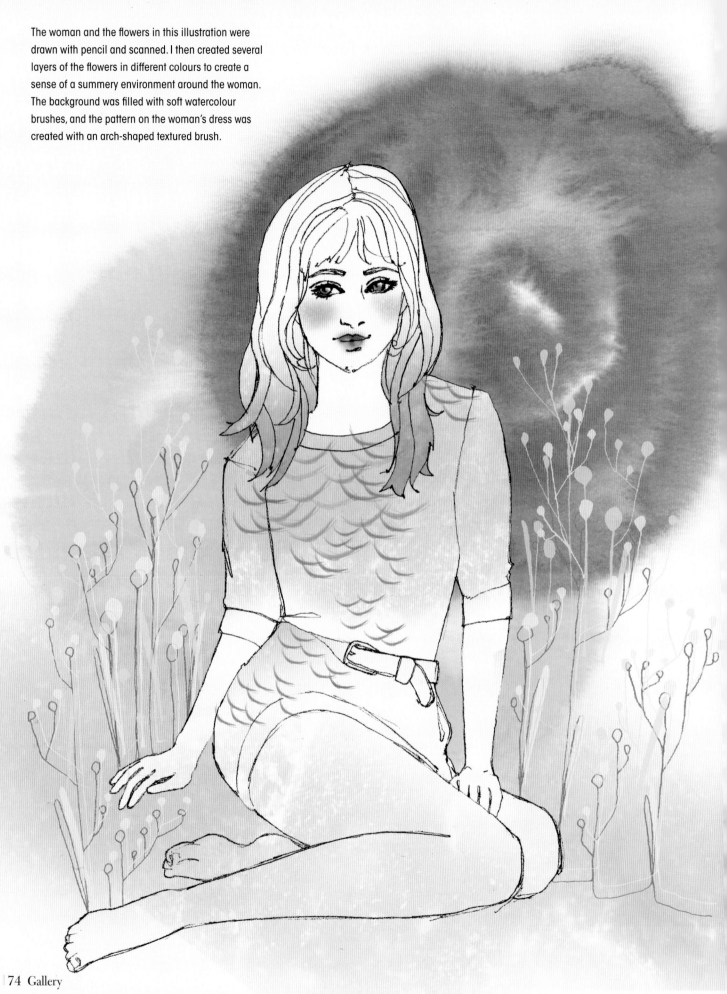

APPLY SCANNED INK MARKS AND DROPS
TO AN ILLUSTRATION

It is possible to apply ink and paint marks using a digital brush; however, you have more control and ownership of the types of textures you apply if you create your own brush marks and textures, ensuring they work well with your drawn illustration.

First apply inky brush marks on a piece of plain white paper, using a thick brush and drawing ink; at the same time, create an additional page of ink splatters by dropping dots of ink with a brush. To prepare these textures to add to your illustration, scan and save the images, then remove the background to your illustration so it is ready for editing (see Create layers to apply colours with the Brush tool). Fill the inky selections with blue and then white in separate layers. The blue and white textures will later be placed onto your illustration.

Tip

I find ink drops, brush marks and hand-painted lettering work really well to create movement and loose colour in an illustration, bringing more of a hand-drawn and less of a digital look.

Now open your scanned line drawing and prepare the image to be edited (see Create layers to apply colours with the Brush tool). Using the Pen tool, draw along the edge of the model's face and her hairline. With the path complete, create a selection by clicking on the dotted circle icon at the bottom of the Paths palette. Create a new layer, and fill the selection with a skin coloured gradient (see Create and apply colour gradients). The colour was quite strong, so I adjusted the Opacity at the top of the Layers palette.

With a soft-edged brush, add a layer of bright blue around the eyes to create the impression of strong eye make-up. When complete, transfer to a hard-edged Eraser tool and rub out the blue areas inside and below the eyes. Use the Brush tool to add soft pinks to the model's lips.

I find it useful to create a bank of inky brush marks and textures, which I scan and save to use again and again for this style of work.

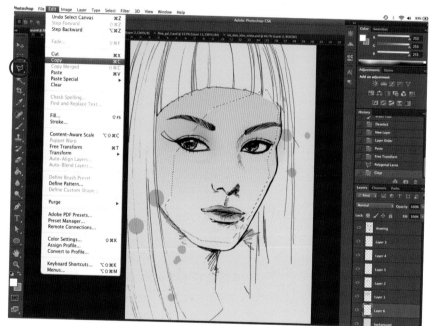

At this stage I want to introduce inky marks to add texture and movement to the background. To do this, open the ink splatters prepared in the first step, making sure you are on the blue layer, and choose Select > All, then Edit > Copy. Return to the illustration and select Edit > Paste. At this stage the inks splatters filled too much of the canvas, dominating the model's face; to adjust, use the Polygonic Lasso tool to draw around the inks inside the model's face, then once a selection is created hit Delete to remove them.

Now select areas of the ink brush marks prepared in the first step by returning to that layer and dragging the Marquee tool across them. Choose Edit > Copy, then return to the illustration and select Edit > Paste. Using the Move tool, position the textures around the model's face then repeat this process with a section of the white ink marks. I felt the white marks on the left-hand side of the model's face worked effectively, but used Edit > Transform > Scale to move the white mark on the right-hand side further outside the model's face to improve the colour layout. To finish, add a brown gradient to the top half of the background and adjust the Opacity to ensure the colour is subtle and muted.

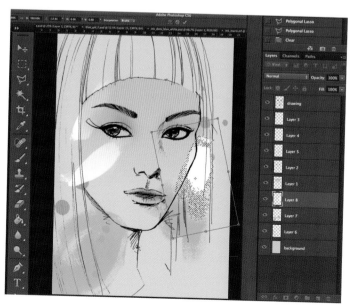

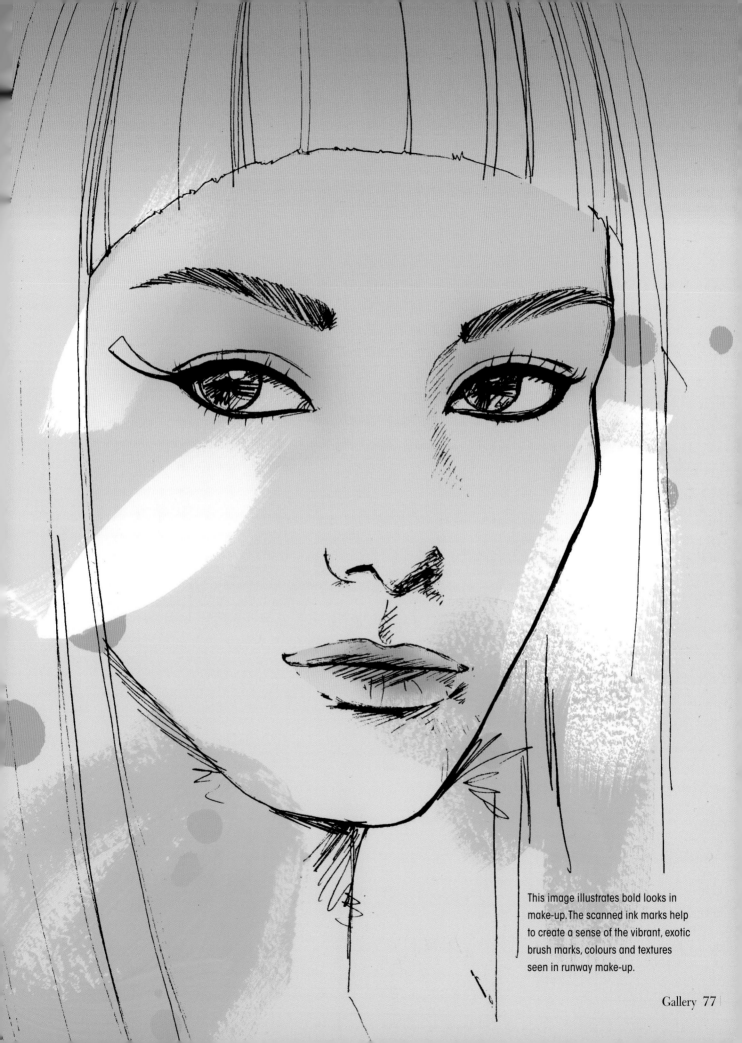

This image illustrates bold looks in make-up. The scanned ink marks help to create a sense of the vibrant, exotic brush marks, colours and textures seen in runway make-up.

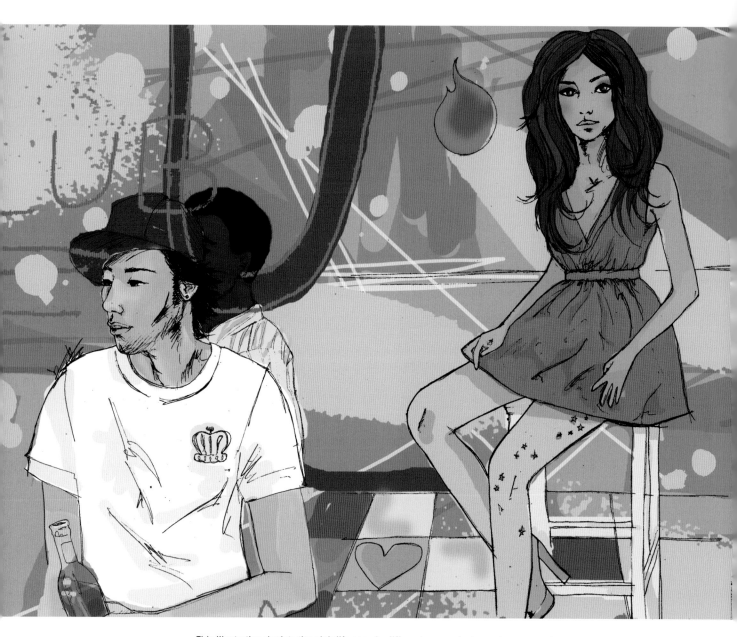

This illustration depicts the nightlife seen in different areas of a bar, using scanned inky textures to create a sense of a lively, colourful mood and atmosphere.

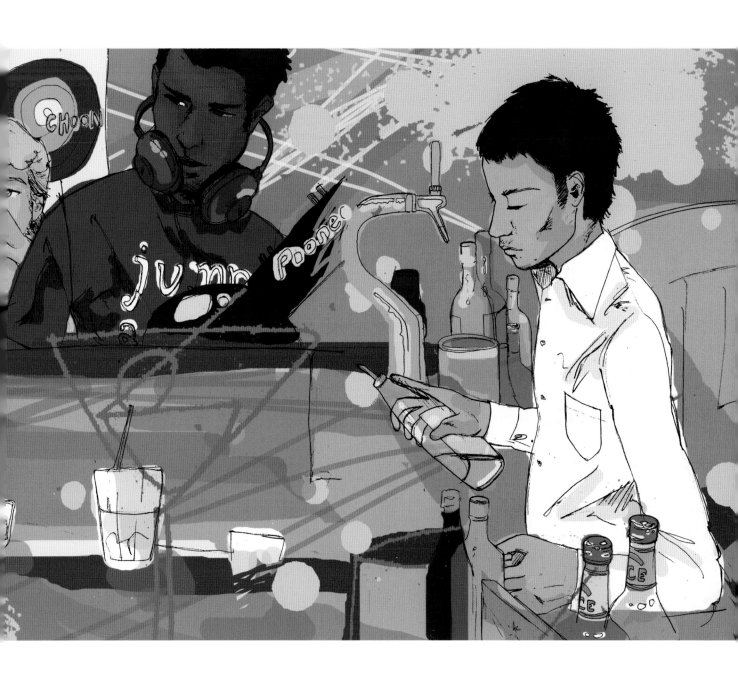

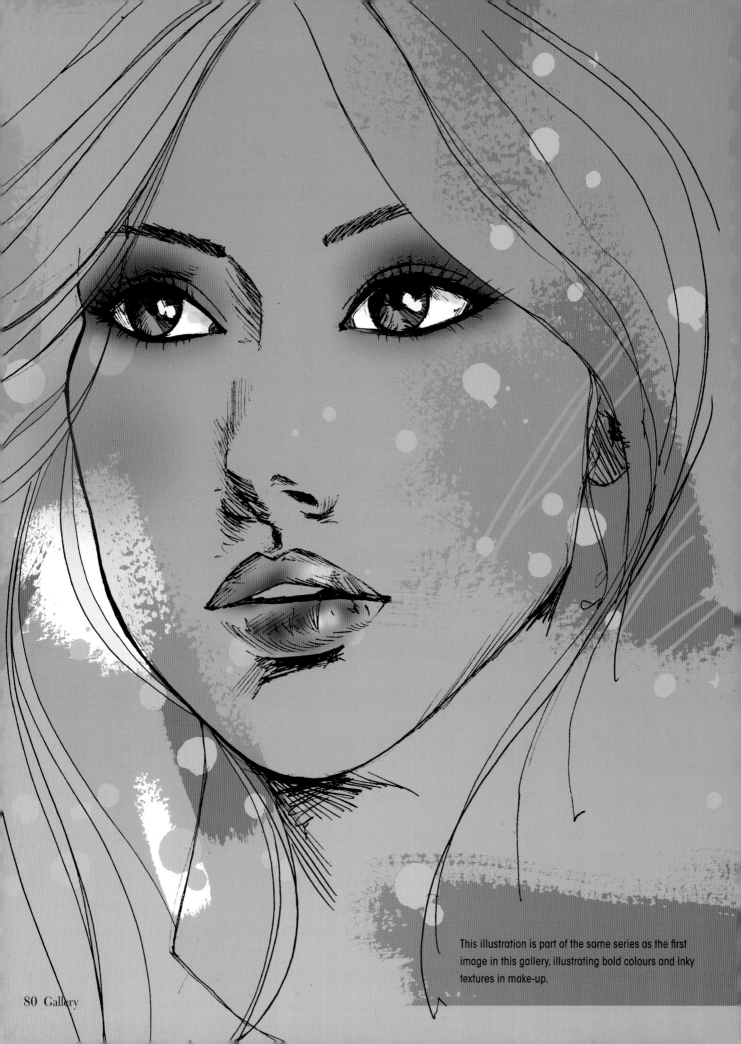

This illustration is part of the same series as the first image in this gallery, illustrating bold colours and inky textures in make-up.

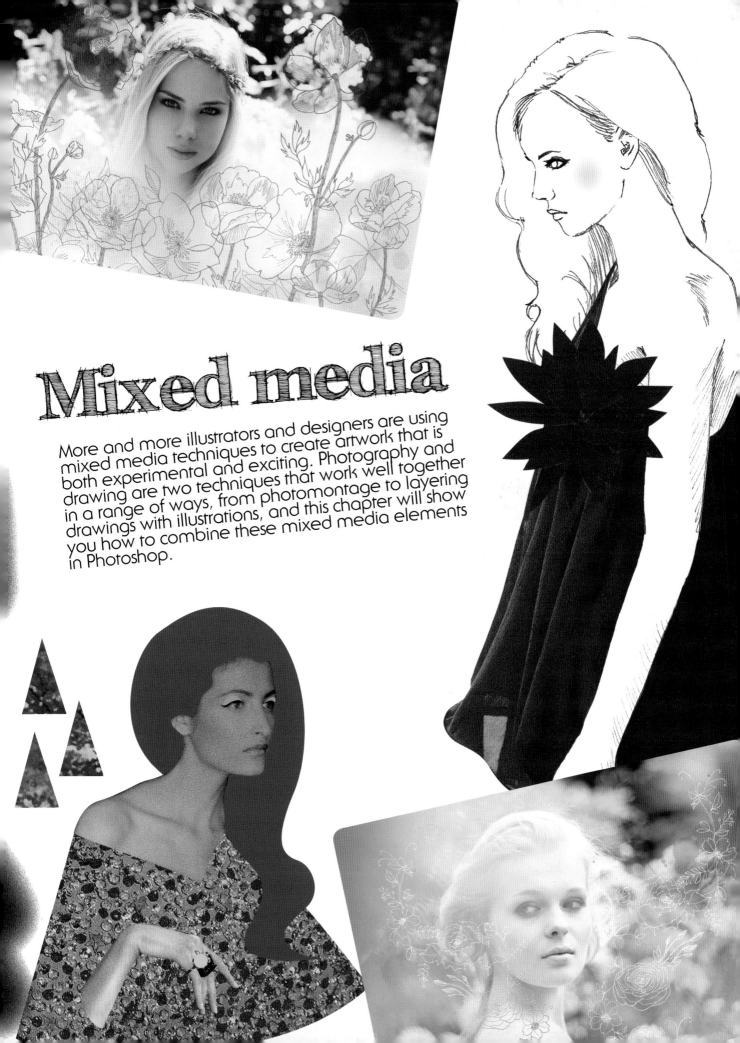

Mixed media

More and more illustrators and designers are using mixed media techniques to create artwork that is both experimental and exciting. Photography and drawing are two techniques that work well together in a range of ways, from photomontage to layering drawings with illustrations, and this chapter will show you how to combine these mixed media elements in Photoshop.

ADD ILLUSTRATIVE ELEMENTS
TO A PHOTOGRAPH

Photography and drawing are two very different disciplines but can work well together, as drawings can enhance or add additional narratives to photographs. It is always exciting to collaborate with other artists and here I collaborated with the talented Thomas Cole Simmonds, a UK-based fashion and beauty photographer, by layering illustrative elements onto his fashion photography (www.tomsimmonds.com).

I chose a portrait photograph by Tom that was not too busy and had negative space, planning to surround the girl's face with flowers to create the impression of a summer meadow. To ensure the drawing does not impose or overlap the model's face, print the photo first then trace a rough outline of the model's face and available space onto a sheet of paper. With these marks in place, draw and overlap flowers to fill the space. Now scan and save the drawing, then open in Photoshop. If the line drawing is too fine, go to Image > Adjustments > Levels and move the black dial on the histogram to intensify the line.

If you are using a photographer's work, always make contact first and ask for permission – many photographers will be willing to collaborate with you. Nowadays more fashion magazines are using this technique in their fashion spreads, where photographers and illustrators collaborate to create interesting results.

I decided to make my illustration bright pink to stand out against the black and white photograph. Remove the white background (see Create layers to apply colours with the Brush tool) and fill the illustration with colour. However instead of filling the selection with black, I chose a pink from the Foreground Color options and filled the area using the Paint Bucket tool.

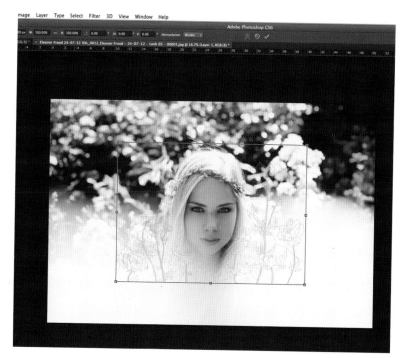

Now go to Select > All, then Edit > Copy to copy the floral illustration. Open the photograph, change the colour mode to CMYK, then choose Edit > Paste to place the illustrated flowers on top of it. Now go to Edit > Transform > Scale to increase the size of the illustration, ensuring you hold Shift to constrain the proportions. Hit Enter when the illustration fits into the canvas and the photograph.

Fashion photography is fantastic to experiment with: I often find simple fashion photographs with areas of negative space or muted colours the best to work with, because they blend harmoniously with the line and colour applied on top.

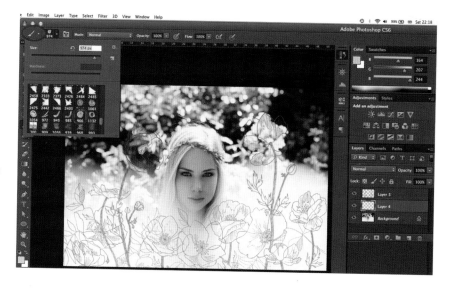

Select the Brush tool along with a soft-edged brush from the Brush palette that is subtle enough to use behind the floral details to add another element of colour to the image. Create a new layer for each new brush mark, in case the composition becomes too busy and you need to delete unwanted layers later.

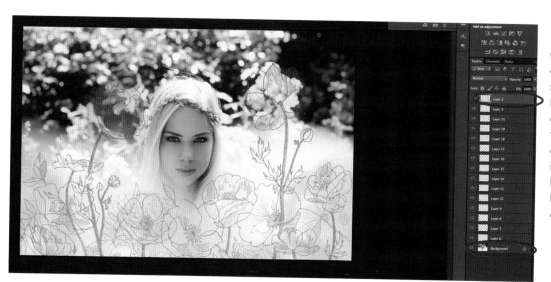

Combine your soft-edged digital brushwork with soft digital watercolour brushes to bring further colour and subtle textures to the artwork. At this stage, always make sure the illustrated layer is the top layer, and the photograph layer sits at the very bottom of the Layers palette.

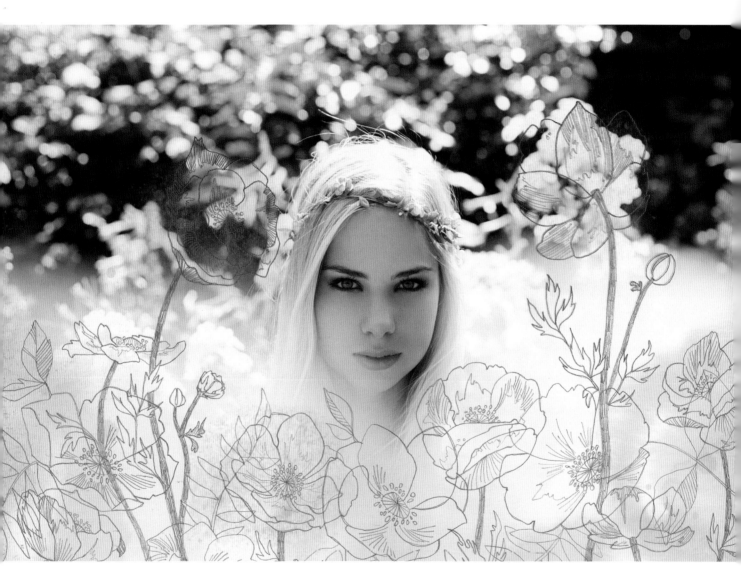

Photography by Thomas Cole Simmonds. The linear floral illustrations
frame the girl's face, evoking a sense of escapism and romance.
Meanwhile the pastel pink flowers sit harmoniously against the soft
black and white tones of the photograph.

Photography by Thomas Cole Simmonds. This fashion photograph was embellished with hand-drawn stars to evoke the freedom of being lost in a big city. The stars were drawn in ink and then converted digitally into black and white to complement the model's monochrome clothing and the sepia tones of the photograph.

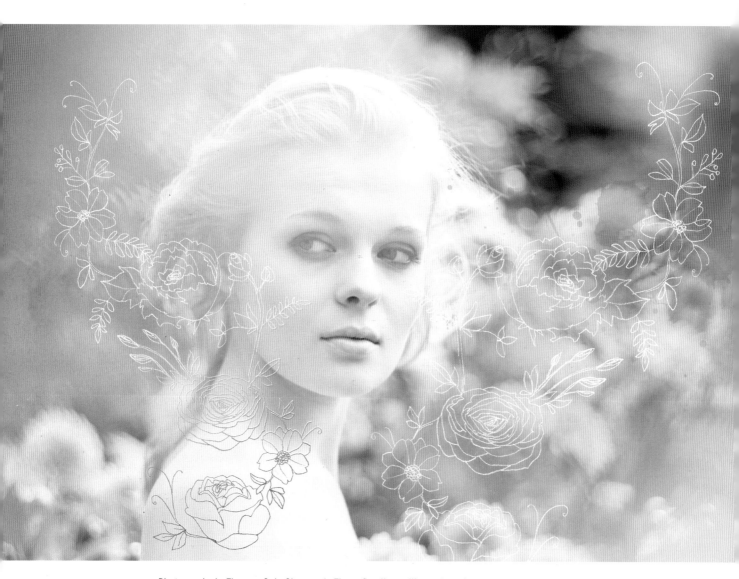

Photography by Thomas Cole Simmonds. These fine linear illustrations frame the model's face, creating a sense of summer and romance. The white outlines of the illustration sit subtly against the hazy depth of field and colour surrounding the model.

ADD PHOTOGRAPHIC ELEMENTS
TO A FASHION DRAWING

Instead of applying illustrative elements to a photograph (see Combine line drawings and photographs), here we'll use photographic elements to bring colour and texture to a fashion illustration. I like to create collages by hand, as I enjoy the spontaneity and hand-crafted look this creates; completing the process digitally is not the same, however it does make it easier to edit and experiment more broadly.

To start, cut out a dress from a fashion magazine then create a floral corsage by cutting out pieces of red paper and gluing them to white paper; scan and save both. To help add the drawn figure element accurately, print out the scanned dress and draw the figure on a sheet of paper placed over the top, using either tracing paper or a light box to allow you to see the collaged elements beneath your paper. When complete, scan and save your line drawing.

Tip

I often leaf through vintage fashion magazines to collect cut outs of colourful outfits and accessories that I like, imagining the clothes on a model in a different pose, or with additional collaged elements.

Now use the Pen tool to trace along the edge of the scanned dress, ensuring you stay as close to the edge as possible. With the path complete, make a selection by clicking on the dotted circle icon at the bottom of the Paths palette then choosing Edit > Copy.

Open your line drawing and prepare the image for colour editing, as outlined earlier (see Create layers to apply colours with the Brush tool). Now go to Edit > Paste to apply the cut out dress on top of the line drawing. You will find that the photographic element may not fit exactly onto your illustration; select Edit > Transform > Rotate then drag the corners to correct the angle of the dress.

Tip

By collecting fashion images in a scrapbook, you will create a constant source of inspiration and reference material. From this, you can choose elements, such as clothing or accessories, to stick or place on top of pencil or pen illustrations, either by hand or digitally.

It is also likely that there will be gaps between the dress and the line drawing, as shown here. If this is the case, use the Clone Stamp tool to fill the gaps: working on the layer with the dress, click Alt on a section as close to the area you want to clone as possible. Adjust the brush size so it is small enough to work with precision, then carefully fill the spaces with cloned areas of colour.

To add a further collaged element to the illustration, use the Pen tool to draw around the floral corsage made in the first step. With the path complete, create a selection, then choose Edit > Copy. Return to your illustration and select Edit > Paste then go to Edit > Transform > Scale to adjust the size and placement of the flower, so it fits on top of the model's dress. Use a soft-edged brush to add a subtle pink blush to the model's cheek and to finish, use the Crop tool to adjust the composition.

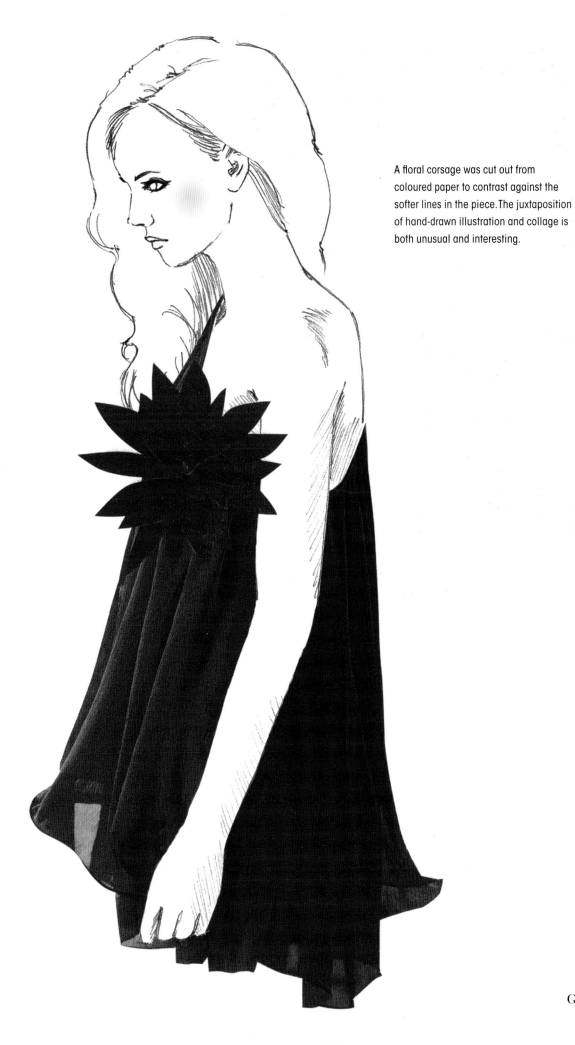

A floral corsage was cut out from coloured paper to contrast against the softer lines in the piece. The juxtaposition of hand-drawn illustration and collage is both unusual and interesting.

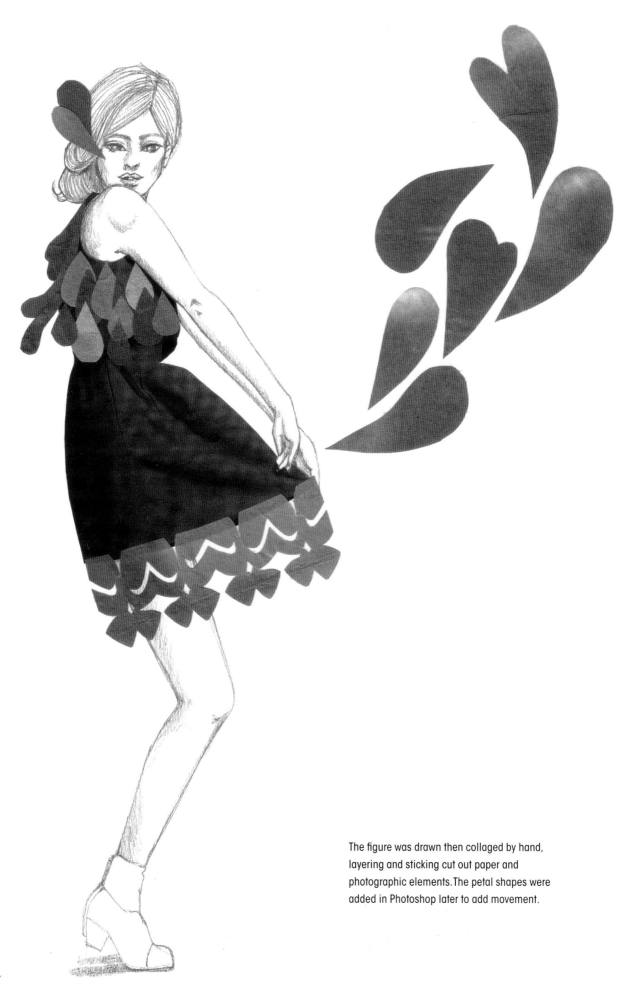

The figure was drawn then collaged by hand, layering and sticking cut out paper and photographic elements. The petal shapes were added in Photoshop later to add movement.

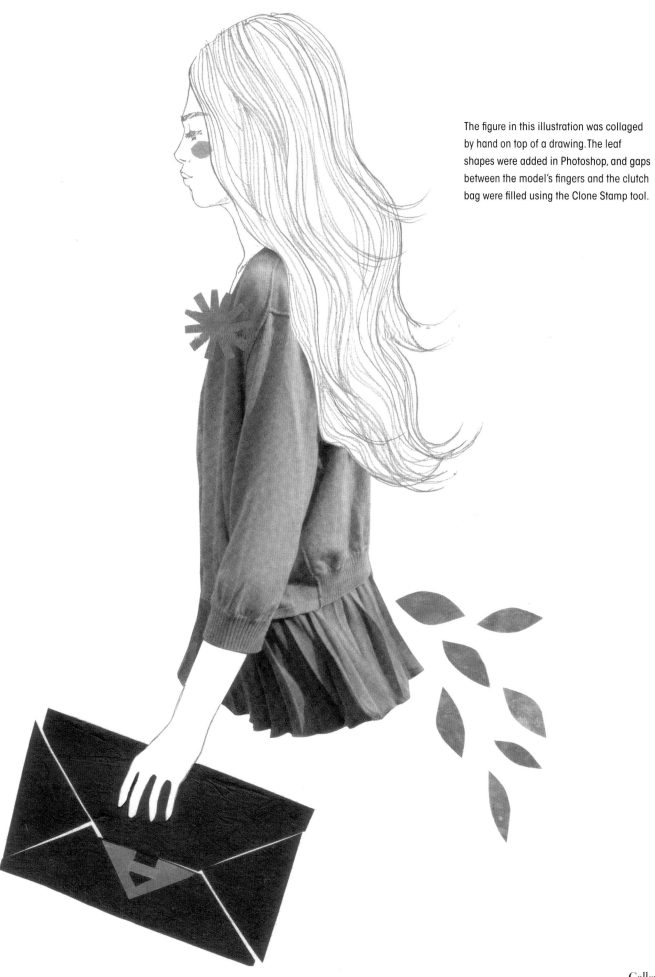

The figure in this illustration was collaged by hand on top of a drawing. The leaf shapes were added in Photoshop, and gaps between the model's fingers and the clutch bag were filled using the Clone Stamp tool.

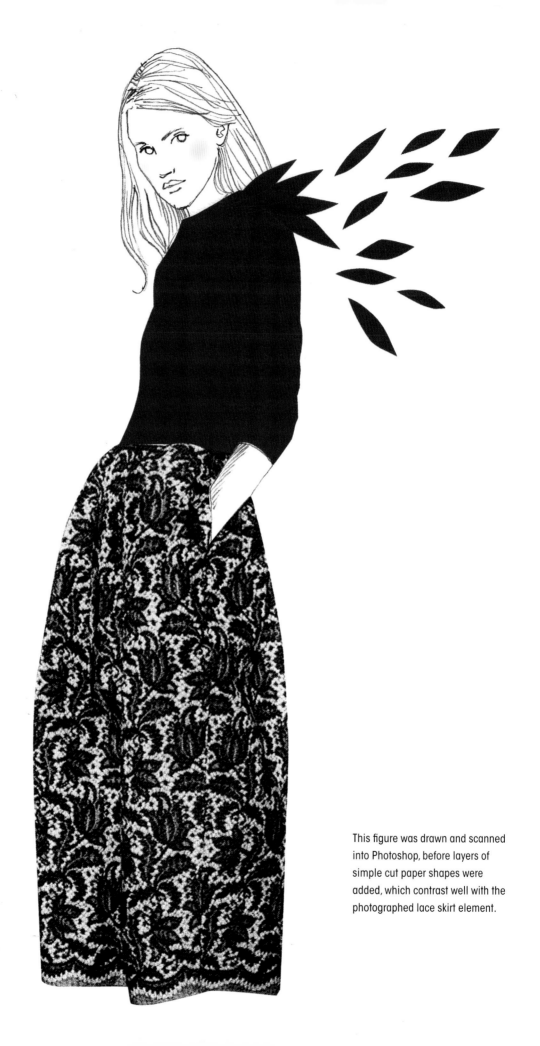

This figure was drawn and scanned into Photoshop, before layers of simple cut paper shapes were added, which contrast well with the photographed lace skirt element.

COMBINE PHOTOGRAPHS AND DIGITAL COLOUR IN A PHOTOMONTAGE

Here we'll learn how to create a photomontage in Photoshop using scanned photographic elements and digital colour. I find that old images help to create the nostalgic feel so often seen in photomontage work, so I chose photos from an old vintage fashion magazine for this tutorial.

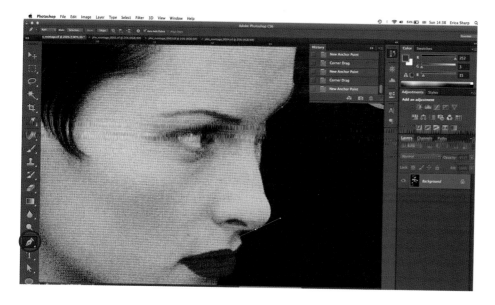

Look through an old fashion magazine and bookmark areas of interest, such as a model's profile, a bright blue eye, or beautiful hands and accessories, imagining what these elements would look like pieced together – then scan them and save. Starting with the photograph of the model's profile, use the Pen tool to trace around the edge of her face. When the path is complete, go to the Paths palette and click on the dotted circle icon at the bottom to make the path into a selection. Then choose Edit > Copy.

I found my old fashion magazines at a vintage bookshop, but you can also buy vintage books and magazines online.

Now go to File > New to create a new canvas at A4 (Letter) size then select Edit > Paste to position the model's profile onto the canvas. At this point I chose to apply an eye from another model's face to add a surreal element to the model's profile. To do this, open the appropriate scanned image in Photoshop then use the Pen tool to draw an oval shape around the eye and eyebrow; make this path into a selection, then go to Edit > Copy. Return to the new document and select Edit > Paste, using the Move tool to place the eye onto the model's profile, then go to Edit > Transform > Scale to resize the eye. I deliberately made sure the eye was slightly too large, to play with the proportions and to maintain a surreal quality.

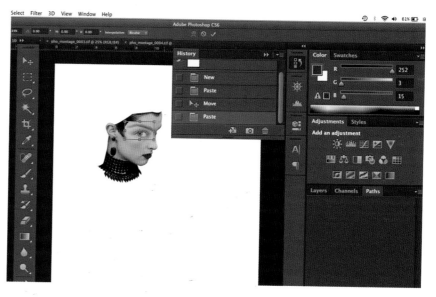

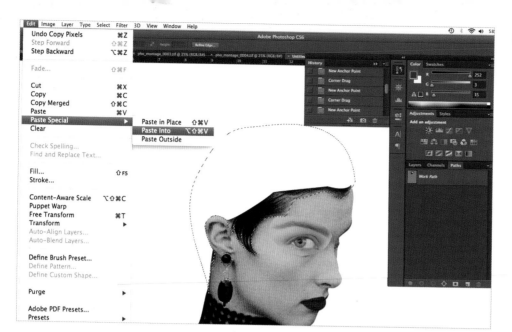

To create hair, use the Pen tool to draw along the hairline then draw what would be the top part of the head. Make this completed path a selection by clicking on the small dotted circle icon at the bottom of the Paths palette, then fill this selection with grass from a scanned magazine page by going to Edit > Paste Special > Paste Into.

Now use the Pen tool to draw a simple shape underneath the model's face to create the impression of a jacket or a cape. Make the completed path into a selection then fill with a bold, flat colour, using the Paint Bucket tool in a new layer. I chose a pastel pink to complement the green colour of the model's hair. Then use the Pen tool to draw around a photo of a hand, make it into a selection, then copy and paste it into the image. The position of the hand did not immediately work, so I chose Edit > Transform > Flip Horizontal to alter its direction to fit correctly with the image.

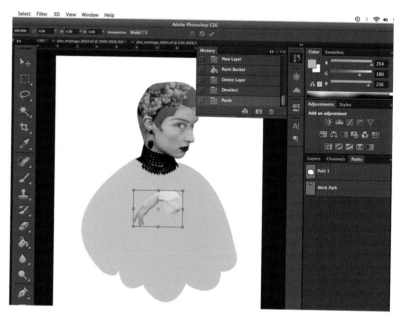

Cut out an oriental-looking bowl using the Pen tool and apply this to the illustration then use the Paint Bucket tool to fill the background with a bright blue colour. To complete, crop the image slightly, to improve the composition.

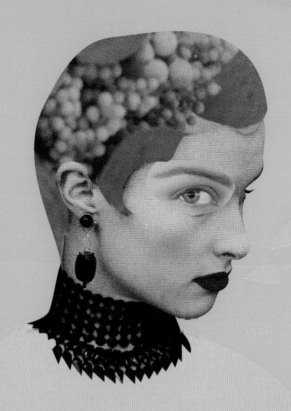

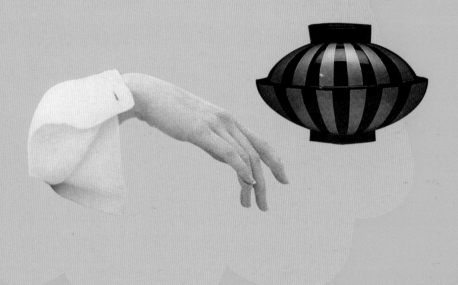

As a modern take on Surrealist photomontages, the pose of the model is elegant and chic, yet the unusual expression and surreal objects bring a sense of humour.

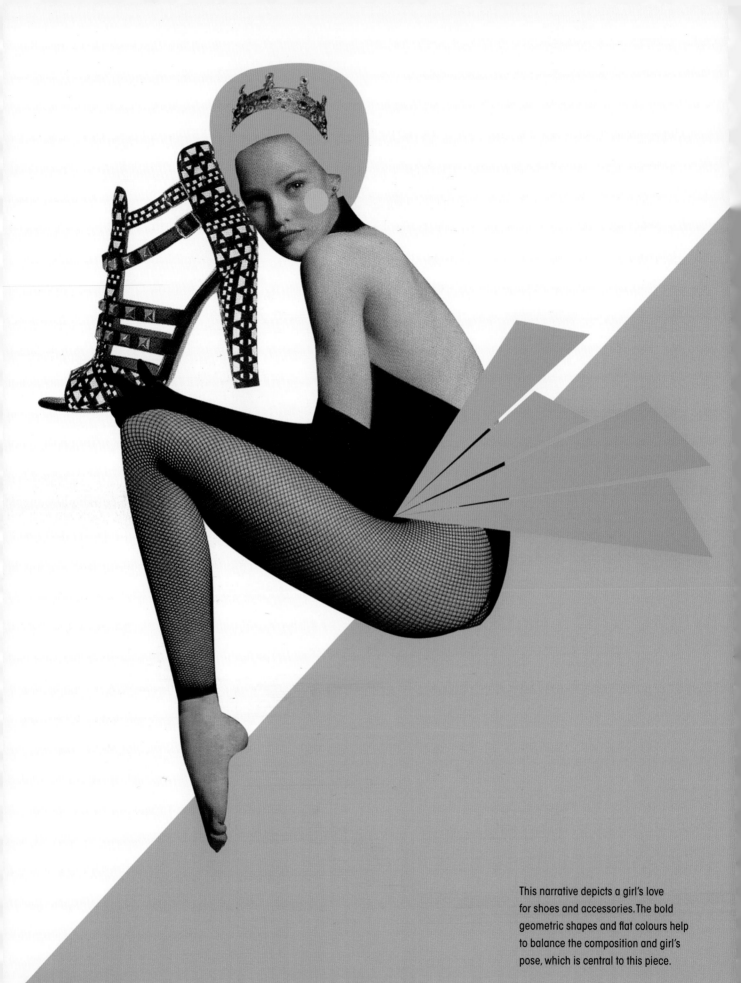

This narrative depicts a girl's love
for shoes and accessories. The bold
geometric shapes and flat colours help
to balance the composition and girl's
pose, which is central to this piece.

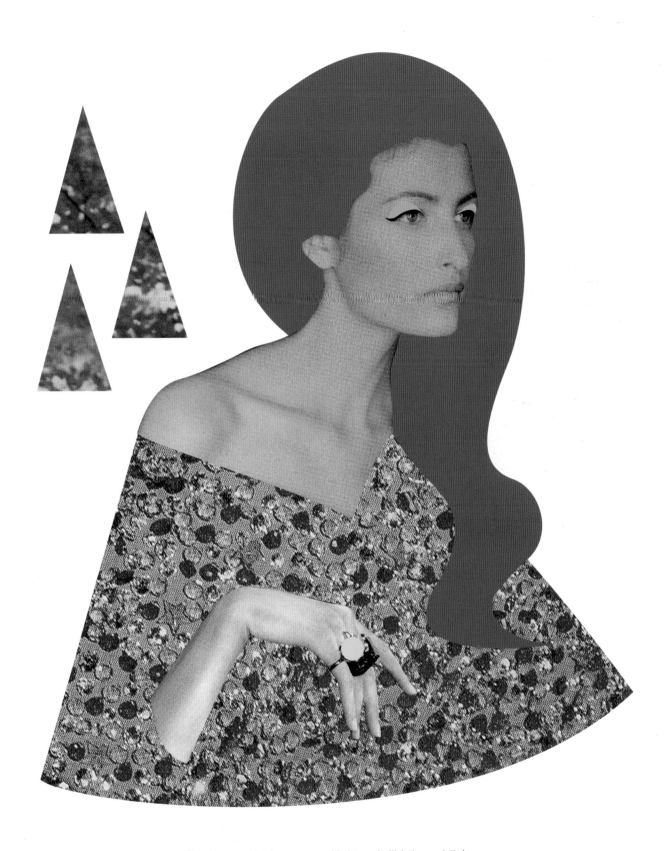

Simple geometric shapes were added to embellish the model's face and clothing with bright, bold colours. Scanned patterns help to add texture to the model's clothing and the trees in the background.

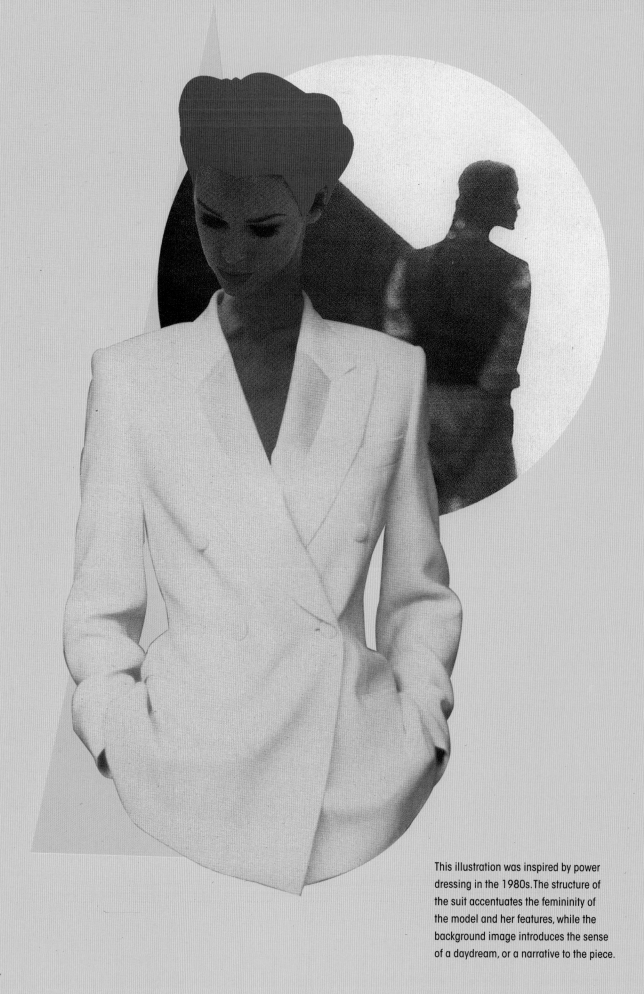

This illustration was inspired by power dressing in the 1980s. The structure of the suit accentuates the femininity of the model and her features, while the background image introduces the sense of a daydream, or a narrative to the piece.

Patterns

Photoshop already has some default patterns available to apply to your fashion illustrations, however I think it is useful and relevant to understand how to design and create your own repeat pattern. Many illustrators also design fabrics and textiles, and the two disciplines run closely in parallel; understanding pattern repeats allows you to explore further afield in your area of illustration and design, as well as making your own fashion illustrations more exciting and colourful.

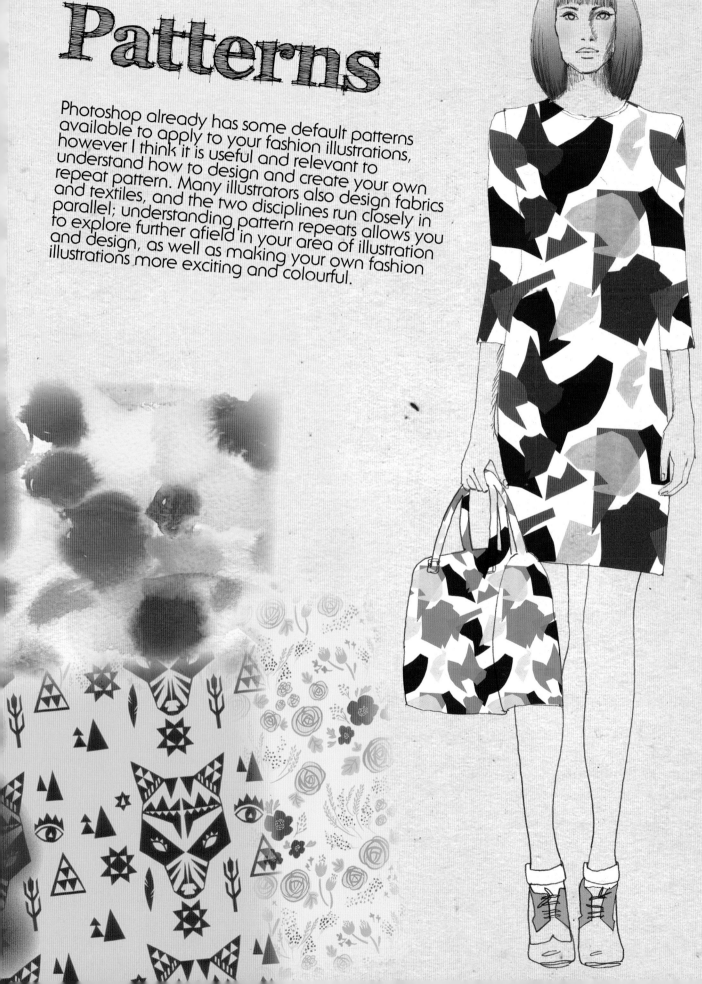

CREATE A REPEAT PATTERN
BY HAND

Here we'll learn how to create a repeat pattern artwork that is ready to scan and edit in Photoshop. This can be done digitally, however I am demonstrating this method as it works best with hand-drawn and painted elements.

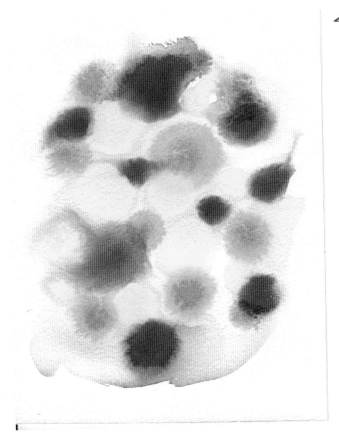

In the middle of a sheet of square or rectangular-shaped paper, draw or paint a design. While doing this, ensure your design doesn't touch any of the paper edges, as this will affect your ability to make the pattern into a repeat. Here I used watercolour paints to create a bright inky pattern in the centre of a rectangular sheet of watercolour paper.

Tip

It is important that you invest in a cutting mat, metal ruler and a good quality craft knife for this technique – you can buy this equipment from an art or craft store.

Once this central design is complete, use a ruler to measure exactly halfway across the top and bottom of the sheet. Mark these points then draw a straight line down with a ruler so the points meet, working as precisely as possible. Once this is done, cut along this line with a sharp craft knife, using a ruler as a guide to ensure the cut is straight. Flip the two pieces then tape them back together on the reverse side using a good quality masking tape, with your pieces as carefully lined up as possible.

Halfway down the edges of the paper, draw a vertical line across – again, be precise. Cut along this line with a craft knife, using a ruler to guide you. Flip these, so the bottom half is at the top and vice versa, with the original outer corners now filling the centre of the paper. Line these up precisely, then tape them back together carefully and neatly.

Tip

Always ensure that you measure accurately, marking your measurements carefully before cutting out your work. Precision really is key here.

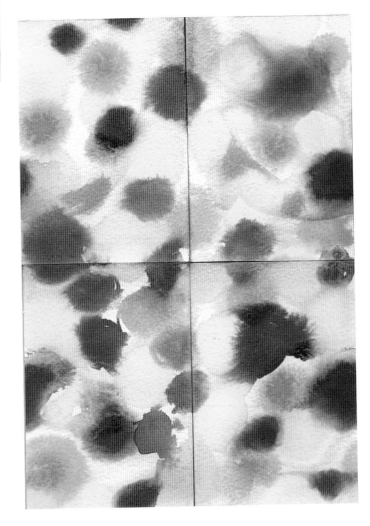

Your design should now be on the outer corners and edges, leaving space in the middle. Fill this space by drawing or painting the remainder of your design, making sure your design is not cut off along the remaining edges of the paper. Once complete, your work is ready to scan and edit in Photoshop.

EDIT A REPEAT PATTERN
IN PHOTOSHOP

With your hand-drawn or painted repeat pattern scanned and saved, you can now edit it in Photoshop so it can be used for the fabric of clothing designs in your fashion illustrations. This tutorial will show you how to create seamless pattern repeats in Photoshop.

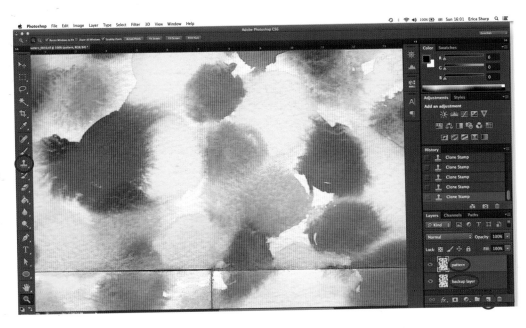

Open your scanned image in Photoshop. Before you start editing, double click this layer and drag it onto the Create New Layer icon at the bottom of the Layers palette. This will create a duplicate so if you make any mistakes, you now have a backup – rename both layers accordingly. The crosshairs where the image was cut into quarters are likely to be visible, so use the Clone Stamp tool to cover these: hold the Alt key and click an area as close to the crosshair as possible, then carefully apply cloned areas of colour to achieve a smooth result.

It is really important that you work meticulously to ensure your pattern repeats seamlessly. To do this, take your time, and always zoom in to the sections you are erasing and cloning, to ensure you are cleaning up the work without leaving any remaining crosshairs or lines.

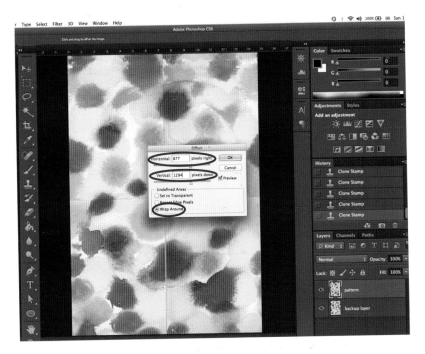

Now go to Image > Image Size to record the image size; write down its width and height in pixels, then use a calculator to divide each measurement in half. Go to Select > All, then Filter > Other > Offset and enter these halved pixel measurements in the horizontal and vertical pixel boxes, also ensuring the Wrap Around option is selected. Now press OK to offset your pattern; this means that the image will be divided in four, with each quarter flipped inwards so the outer edges and corners now sit as inner cross-sections of the image.

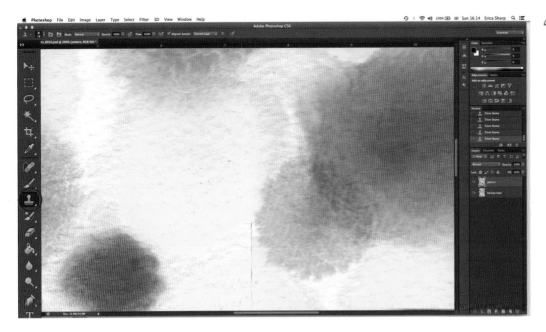

Because you have offset the image, any gaps or inconsistencies from the outer edges of your image are now visible as central crosshairs. Use the Clone Stamp tool to erase them. Save your work as a .tif file, go to Select>All, then Edit>Define Pattern, and rename your pattern, e.g. "watercolour 1". This action saves your pattern tile so you can later repeat it simply and easily.

In the Layers palette, select the Adjustment Layers icon at the bottom of the window then choose the Pattern Fill option. Type 50% in the Scale box to see your pattern tile at a 50% reduction in size, as a repeat pattern. You can then use the Zoom tool to view the pattern close up to ensure that there are no crosshairs or lines left visible, and that your repeat pattern is seamless. If you are happy with your pattern, simply delete the adjustment layer. If you need to make further changes, delete the adjustment layer and return to your edited work, making the final necessary tweaks; then repeat the adjustment layer stage to check that any corrections were successful.

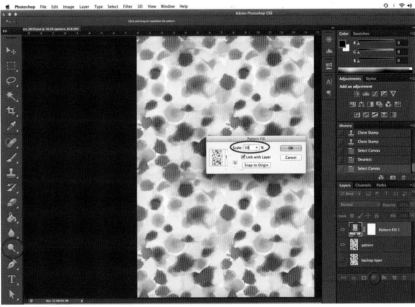

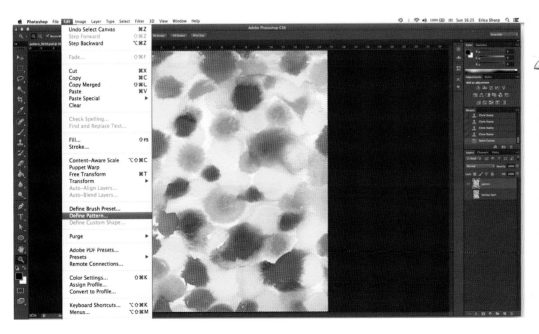

If you have made further adjustments to your pattern, you will need to go to Select>All, then Edit>Define Pattern, and rename your new pattern, e.g. 'watercolour 2'. Save your work as a .tif file, so it is ready to apply to a fashion illustration at the next stage.

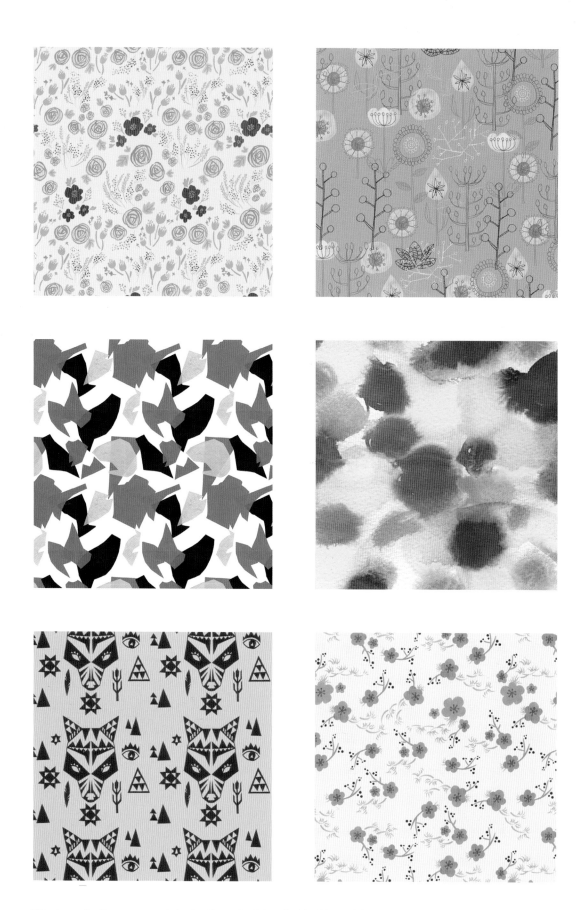

This range of patterns was created using the method described in this tutorial, combined with editing and manipulation in Photoshop. All the patterns were initially created by hand with either watercolour or gouache paint, cut paper elements, or hand-drawn in pen or pencil, before being scanned and edited digitally.

APPLY PATTERNS
TO A FASHION DRAWING

Now that you know how to create a repeat pattern, you will hopefully be inspired to create a bank of different ones that you can apply to your fashion work. This is a great way to showcase your patterns, and may be useful if you want to make your patterns into print, or if you are working on producing patterns for a fashion company.

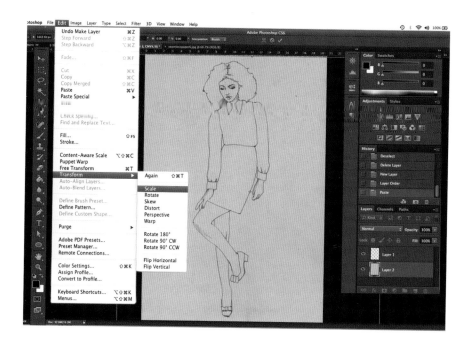

Scan and save your fashion drawing, then open it in Photoshop. Prepare your illustration so it is ready to be edited (see Create layers to apply colours with the Brush tool). Now place a textured paper scan into the background by copying and pasting it into the Background Layer, then using Edit > Transform to adjust the scale so that it fits the canvas.

Draw fashion figures that suit the style of pattern you are going to use to embellish their clothing. Here I was inspired to create colourful, retro patterns, so I drew models in a style to suit this vintage feel.

Use the Pen tool to draw around the outline of the model's blouse. I want to apply a different pattern to the skirt, so I have not yet outlined this part. Once your path is complete, make it into a selection by clicking the dotted circle icon at the bottom of the Paths palette.

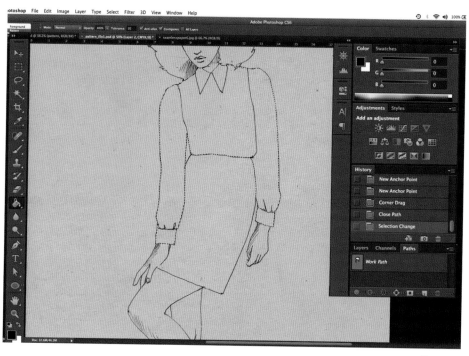

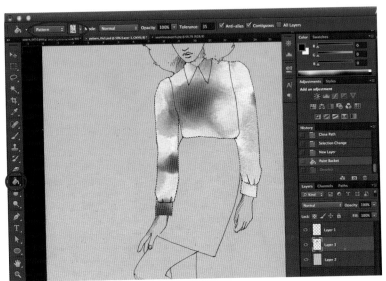

Select the Paint Bucket tool then choose Patterns from the drop-down options in the Menu Bar to select the pattern created earlier from the thumbnails. Choose your pattern, create a new layer, then fill the selection with this pattern. Here the pattern has displayed too large in comparison to the model's blouse, so delete the layer. In the next step, we'll return to our original pattern tile to adjust its size.

You may find that when you first apply your pattern repeat to your illustration, the repeat is too large; it is important to experiment with the size of the repeat to discover what best suits your illustration.

To make the required adjustment, open the pattern tile that you created earlier, then go to Image > Image Size and halve the image's existing size. Choose Select > All then Edit > Define Pattern, where you will have the option to name your resized pattern. I would name it something other than your original pattern name; for example, if you named your first pattern 'Inky' then name your resized pattern 'Inky2'.

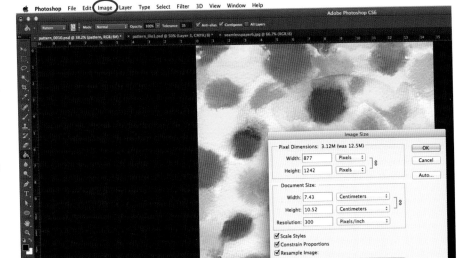

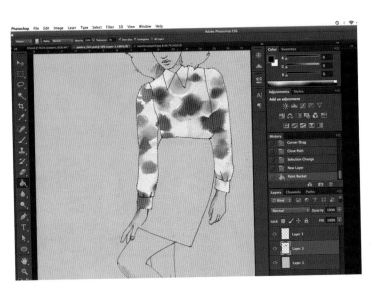

Return to your illustration and create a new layer, then fill the model's blouse with your new resized pattern from the drop-down options at the top of the screen. Now create a path around the model's skirt to fill it with the same pattern, but in a new colour variation. To do this, return to your resized repeat tile and adjust the colours by selecting Edit> Adjustments > Hue/Saturation then adjusting the Hue dial. Now choose Select > All then Edit> Define Pattern, renaming your new pattern something like 'Inky_blue'. Fill the skirt with the blue variation, applying further accents to the remainder of the model's clothing using the Brush tool.

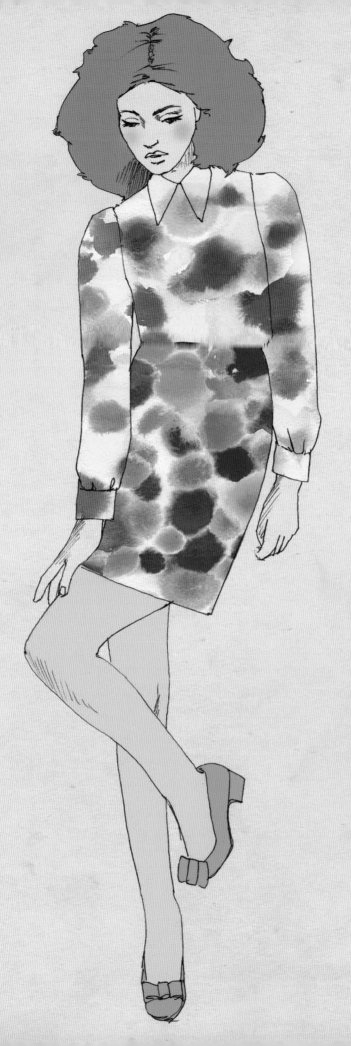

The illustrations in this gallery
were inspired by the bold
patterns of the 1960s and 70s.
The colourful inky dots work well
with the bright stockings and
accessories the model is wearing.

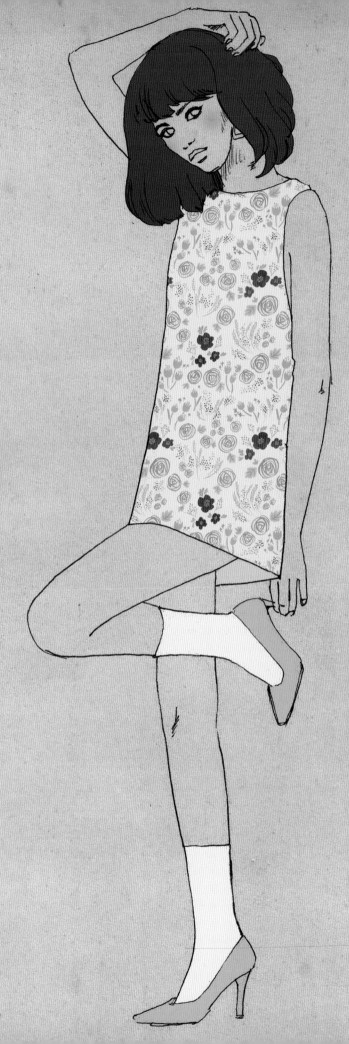

This playful, youthful pattern matches the 60s-style shift dress worn by the model, and the bright colour complements the pastel-coloured socks and shoes she wears. This pattern was painted with gouache paint before digital colour was added into the background in Photoshop.

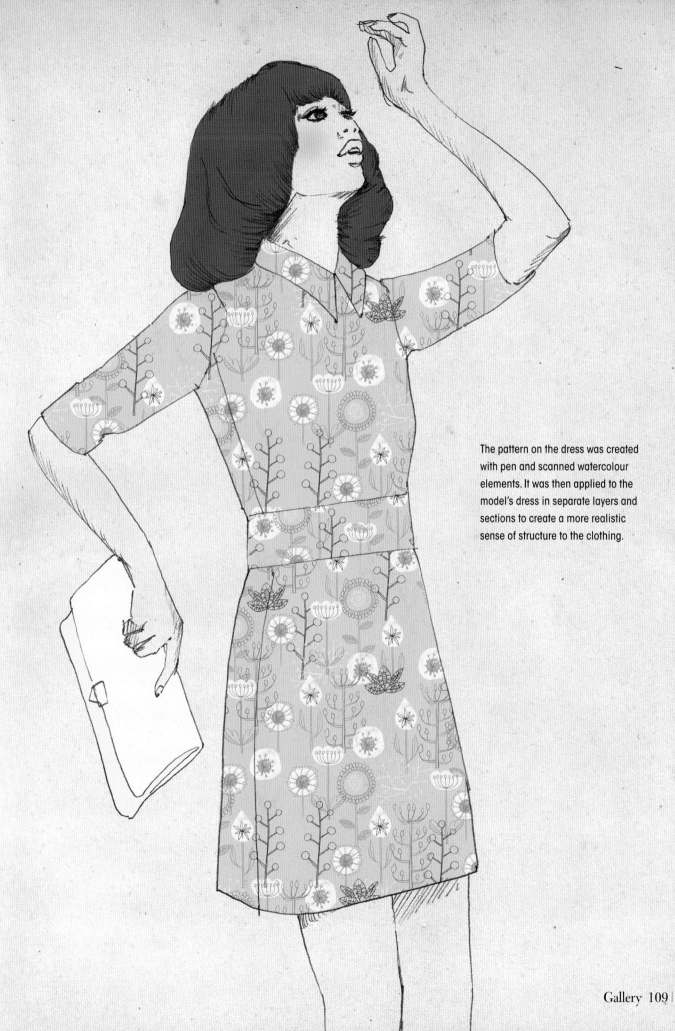

The pattern on the dress was created with pen and scanned watercolour elements. It was then applied to the model's dress in separate layers and sections to create a more realistic sense of structure to the clothing.

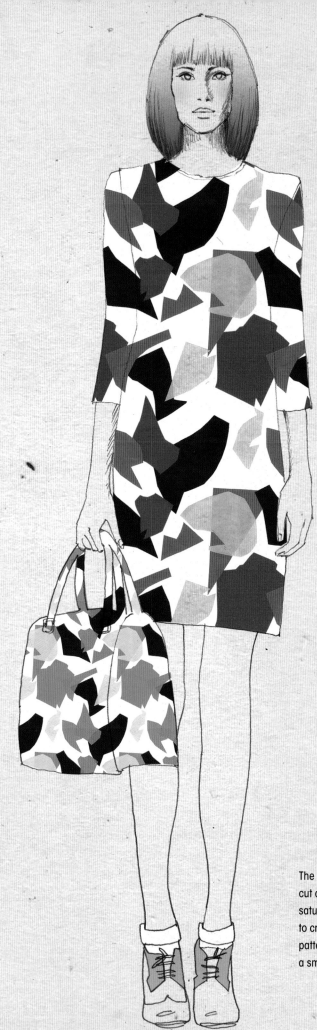

The pattern used here was created with
cut out paper elements. The hue and
saturation of the colour was adjusted
to create a blue version of the original
pattern, which was then applied as
a smaller repeat on the model's bag.

A career in fashion illustration

There are integral elements that are all equally important in helping to create a successful career in fashion illustration. This chapter will explore these elements, which include generating ideas, practising and developing your skills, developing your own style, and successful self-promotion, both traditionally and online.

GENERATING
IDEAS

Illustration is built upon ideas and concepts, and visually communicates a message; for example, highlighting specific points in a magazine article, or illustrating the current season's fashion accessories. In a commercial sense, the starting point for ideas is the creative brief. There are many areas that could get you work as a fashion illustrator, such as magazine and editorial work, advertising, and fashion apparel. In all of these specific areas, a creative director conveys the vision for the project and reinforces the ideas behind the brief to ensure that you, the illustrator, will communicate the idea or concept clearly through your style of illustration.

It is important, therefore, to create a body of work that is based upon a concept or an idea. One way of practising this is to set yourself a brief. Look in fashion magazines, and if there is a particular article or feature that inspires you, illustrate it. Illustrate parts of a book, or create a front cover. Stay up to date with current fashion designers, and use their collections as a starting point to illustrate particular trends or looks. I find that keeping sketchbooks is a fantastic way to record ideas quickly and loosely, and at the same time be experimental and practise your drawing skills.

These quick sketches were drawn based on Hollywood fashion at the Oscars. I find it useful to add colour to an illustration quickly using paint, colour pencils or collaged paper to give a sense of the colour, texture and structure of the clothing the models are wearing. If sketches are successful, or I want to do more to them, I continue to create a more polished version. They are also useful to keep as reference material for future work.

PRACTISING
YOUR SKILLS

As a fashion illustrator you need to be confident in drawing figures, so I highly recommend that you draw from life as much as you can. Attend life drawing classes, as they can really help you improve your observational skills and help you gain fluency in the way you draw people. If you can, attend fashion shows and make some sketches in your sketchbook; you can take photos and collect images and resources while you are there, too. Keep practising and challenging yourself as much as you can. At the same time, it is a good idea to keep your drawings, so you create a 'bank' of sketches that can be incredibly helpful as supportive reference material further down the line.

These sketches are from my life drawing book, which I complete from direct observation or from photographs. I try to choose challenging poses or angles, as doing this helps improve my drawing skills. Drawing hands and feet is always quite tricky, as is portrait drawing from different angles, so I try to practise these as much as I can.

DEVELOPING YOUR OWN STYLE

Combine your practice of figure drawing with a love for representing things in a beautiful, appealing way. Fashion illustration can represent a particular item of clothing, mood, or pose in a stylized way, using different materials and mediums. There is a real element of fantasy in fashion illustration, with great scope for experimentation and stylization.

One way of developing your own style is to collect images that inspire you and there are many ways in which you can do this. I recommend buying fashion magazines or runway catalogues, because they help you stay in the loop with fashion trends and designers – they are also full of wonderful, inspiring images. You may find an interesting photograph of a fashion model, whose pose you want to emulate in your own illustration, or a particular outfit that you like the pattern or structure of.

Fashion books are also a fantastic source of inspiration, and a great investment. Visit art and design museums, as many exhibit the work of fashion designers and illustrators. Collect your own library of inspiration and reference material; you are guaranteed to return to it each time you create a new work or receive a new brief. I would also recommend using Pinterest (www.pinterest.com), an online pin board where you can collect and organize images, keeping them online for your own easy reference.

Pinterest is a fantastic way to collect inspiration online. It enables you to create 'pinboards' with different themes, such as fashion illustration, patterns or fashion photography. You can then easily 'pin' images you discover on the Internet to the relevant board. You can also create 'secret boards' for your own personal projects.

As well as generating a continual flow of inspiration, it is important to maintain consistency in your own style and the way in which you present your work. There is nothing wrong in experimenting with different styles and materials, but aim to present yourself in the commercial world as an illustrator with your own distinctive style. This may be in the way you apply line, colour and negative space in your work, or a particular medium that you prefer to work in. Be prepared to be flexible and adapt with the times – like fashion, fashion illustration evolves, so keep in touch with current fashions and styles.

Over time, from galleries, museums, bookshops and magazines, I have built up a collection of inspiration and reference material that helps me get started with ideas when creating illustrations. I also often buy fashion and runway annuals, as they keep me up to date with current fashion designers and trends, and keep me inspired.

SUCCESSFUL
SELF-PROMOTION

To be a successful illustrator, you need to practise your skills continuously and move with the times, but you also need to get your work seen through as many avenues as possible. Active self-promotion is a key part of the process of becoming a successful illustrator, and there are various ways to get your work seen.

An active illustrator is someone who immerses themselves in their field both inside and outside of work, through entering competitions, attending events, and visiting galleries and relevant exhibitions. Getting yourself out there and actually meeting people is a very powerful tool, and its impact is easy to undervalue. My first commission was the result of entering a fashion illustration competition in a popular women's fashion magazine. I didn't win the competition, however the art director held onto my work because she liked it, and I was later asked to complete the next six months of horoscope illustrations.

Another thing I did when I was fresh out of university was to create a portfolio of work. I used this to contact illustration agencies. It is a very competitive field, and I didn't get signed up with anyone as I had hoped, but one of the agencies was kind enough to agree to meet me to talk through my portfolio and their advice was invaluable, really helping me to focus on developing a stronger signature style. Experiences like these demonstrate that it is so important to get yourself out there, meet people in the field, and get your work seen, even if it means entering competitions or doing the occasional unpaid job. I am a firm believer that grabbing opportunities like these can often reap rewards further down the line.

A relatively low cost way in which you can get your work seen is to arrange for business cards and postcards to be

These business cards were printed by Moo (www.moo.com), and are a convenient and low cost way to promote yourself to contacts. I always carry business cards with me when going to events, or anywhere where I think I may meet useful contacts or potential clients.

printed for sending out to potential clients, magazines and publishing houses, or for dropping off to independent galleries. There are plenty of fantastic online printing companies who offer a wide range of products – business cards, postcards and greetings cards – that you can easily customize with your own illustrations. Always make sure that your name, website and email/phone number is visible on your cards so potential clients can easily contact you.

Although a little more expensive, these concertina cards are a fantastic way to promote what you do by showcasing a range of illustration work to potential clients. I send these out about once a year to magazines and publishers.

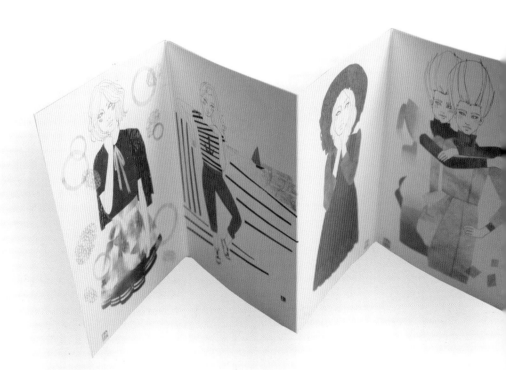

Each year I like to spend a little more money on creating something a little more fancy in terms of self-promotional material. I find concertina cards are an excellent way to showcase a range of illustrations; they can be displayed, and are a little more special than a standard postcard. Also, they are not too fussy and can be folded away for art directors to keep if they are interested in your work. Concertina cards can be printed at any reputable printers but are a little more expensive, so it may be worth waiting until you feel you are more established before investing in something like this – but I do believe it is worthwhile.

So, where do you find contact details of potential clients? Every six months or so I like to visit a good, independent bookshop and look for magazines that include fashion illustrations. There are plenty of mainstream magazines that use these and are on the lookout for new and exciting styles. There are also plenty of independent publications, many started by creatives, looking for images to illustrate articles and features, or to showcase the work of illustrators themselves. I find it useful to jot down the addresses of these magazines or publishers, as well as the names of art directors, so I can later send out promotional postcards or packs through the post.

It is also worth contacting the Association of Illustrators or the Society of Illustrators (see Useful contacts), as they offer membership and support for illustrators; the AOI also provides directories full of useful contacts in the editorial and advertising fields. Moreover there are various handbooks for artists and writers, which contain useful contacts and potential clients that you could call or send promotional packs out to.

Another great way to get your work seen is through illustration annuals, which usually have a large print run and are sent to art directors and advertisers, making them a very effective way to get your work seen by those in the industry. The Association of Illustrators (UK) and Communication Arts (USA – see Useful contacts for both) amongst others release an illustration annual each year that showcases the best of illustration. They collect entries for this by announcing an open call for illustrators to submit their work to be selected; there is usually a fee to enter, but many are reasonable, and worthwhile. You can stay updated on these open calls by looking at their websites, or searching for illustration annuals.

Try to build friendships with other illustrators (this is easy to do now through social networking), as you may wish to form a collective, or organize a group show or live drawing event together. If this is the case, it is worth contacting some smaller, independent galleries to see if they can offer a space for a group show; they may also have a shop where you could sell prints or greeting cards, or an open call or competition coming up.

 Having work published in illustration annuals and art publications is an excellent way to promote your work and gain exposure. This feature was published for Digital Arts Taiwan and helped me promote my work to the Eastern market, and to creatives and directors based in Asia.

ONLINE SELF-PROMOTION

The Internet is an incredibly powerful platform from which to make contacts, build a website, write a blog and get your work seen by a potentially wide international audience. The most valuable tool you will use to continually promote and market yourself as a fashion illustrator is your own website, which is a place where you can keep and update your work, and where potential clients can find you.

When starting up your website, make sure you have a domain name that represents you, ie www.yourname.com, also avoiding long or complicated domain names. In fact, I highly recommend investing in a hosting website so you have your own personal web address. This demonstrates a professional approach; art directors and clients will not take you seriously if you use a blog site as an online portfolio.

Register your domain then build your website, using one of the many pre-built web platforms that are now accessible to creatives who have no knowledge of web design. I recommend Cargo Collective (www.cargocollective.com), as they offer beautifully designed layouts at a reasonable price, and the websites here are easy to build without any knowledge of HTML – yet there are plenty of other sites just like this.

Cargo Collective is an excellent resource that allows you to create a beautifully designed website, without knowledge of HTML and with your own personal domain name, for a reasonable fee. Cargo Collective is also a network for creatives, and allows you to follow other designers and artists, staying in the loop with their updates and new work.

This is my own personal website, which showcases my portfolio online. I personally find simple, easy-to-navigate layouts the most appealing, which allow your work to stand out and speak for itself.

A good website should be easy to follow and not over complicated. I would avoid using any music or flash, as this can be distracting. Set the website out simply as your online portfolio (see Creating your online portfolio) with clear categories – fashion illustration, lifestyle illustration, textile design, contact page and about page – and use a clear, strong image for your homepage to draw the viewer in. These types of categories are easy to set up on websites such as Cargo Collective, and uploading a gallery of images under each category is relatively straightforward, too.

Once you have your website and/or blog in place, use social networking as much as you can so your work becomes seen. Twitter is incredibly useful for networking and making contacts: follow people that work in the same creative sphere as yourself – fellow creatives, art directors, illustrators and designers. It is worth using hashtags to label keywords in Tweets – for example, new illustration on my blog #fashion #illustration – as this helps to draw in an audience that shares the same interests as you. I also recommend following magazines, publishers and advertising agencies, as there are sometimes open calls or competitions, and it is useful to stay in the loop with what is going on in these fields. Facebook is also a powerful tool to receive regular updates from companies, agencies or publishers; nowadays most have a Facebook page, and it is equally easy for you to set up your own page, to upload new work, create new contacts, and post regular updates.

Twitter is an incredibly powerful tool to stay connected with fellow illustrators, publishers and magazines, as well as illustration blogs and agencies. It can take a while to establish yourself through Twitter, but by following users who have the same artistic interests and interacting with them, you can soon create great networks and access to creative opportunities, competitions and events.

Blogging sites such as Wordpress or Tumblr are also fantastic for writing about your work, or for more informal, regular updates.

As well as setting up your own web presence, I would recommend staying in touch with the illustration world through a selection of widely-read illustration blogs. Many offer the opportunity to upload a profile that links back to your website, or to post news stories and features. It is worth contacting illustration bloggers and emailing them a link to your website, too; many will feature you on their blog if they like your style of work and this is great publicity for you, helping people see and read about you and your work.

Finally, if you want to sell items such as fashion illustration prints, websites such as Etsy (www.etsy.com) are a fantastic platform from which to sell your work to an international audience. Etsy is a hugely popular website, selling arts and crafts by independent creatives, and many fashion illustrators sell prints, greeting cards and postcards through this avenue with great success.

Etsy is an effective platform from which to sell work, and fashion illustrations are incredibly popular for purchasing in the form of prints, notecards, postcards and clothing products. An Etsy shop is easy to set up, and there are helpful forums that will guide you in creating contacts and becoming part of this creative community.

CREATING YOUR
ONLINE PORTFOLIO

The first objective once you have got your website up and running is to publish your online portfolio, showcasing illustrations in your own style that have been driven or self-directed with a commercial concept or avenue in mind. You should aim to showcase a body of work in which potential clients and art directors recognize a consistent style, and commercial potential.

Over the next few pages are some examples of my own stylized illustrations that I created with a commercial direction in mind, such as runway fashion, beauty, lifestyle, sport, travel, and horoscopes.

Horoscope: The first commission I received as an illustrator was for horoscopes in a women's magazine. Go to your local stationers or bookshop and look at women's magazines that have illustrations in them; you often find the horoscope sections are illustrated. Create your own set of horoscope illustrations, which you could include in your promotional work or website.

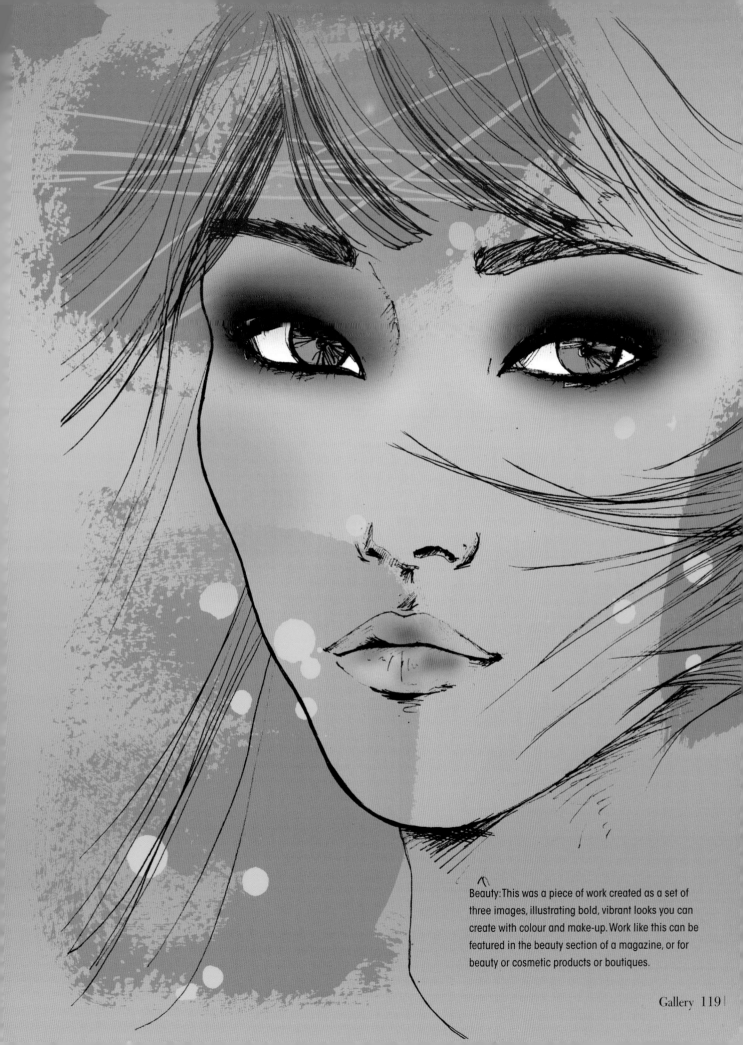

Beauty: This was a piece of work created as a set of three images, illustrating bold, vibrant looks you can create with colour and make-up. Work like this can be featured in the beauty section of a magazine, or for beauty or cosmetic products or boutiques.

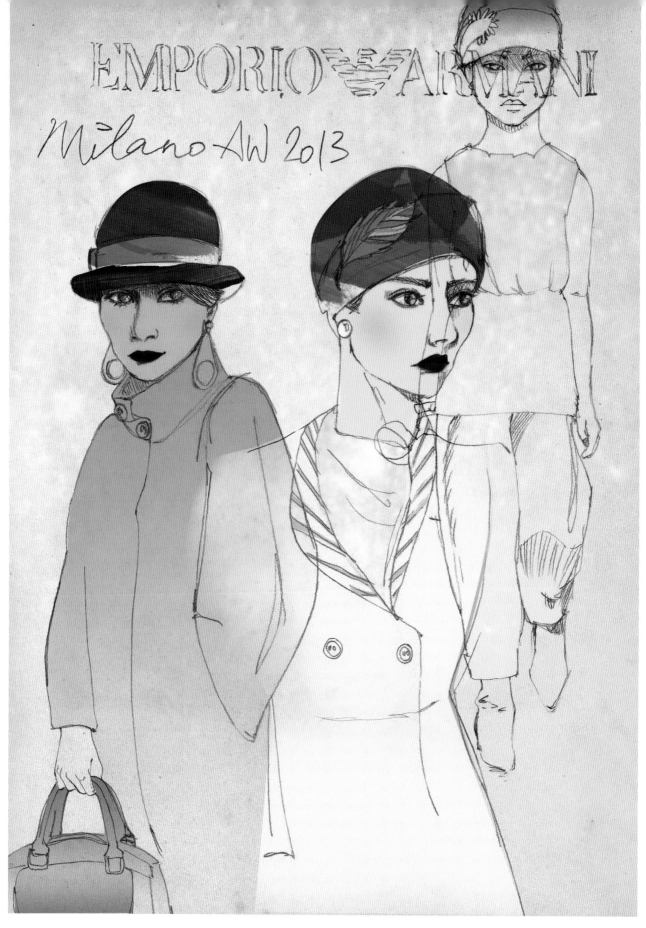

Runway: Runway or high fashion illustrations can be used to promote events such a fashion shows, or in magazine articles or advertising. Stay in touch with current fashion designers; their work is inspirational, and can also help you create stylish work with commercial potential.

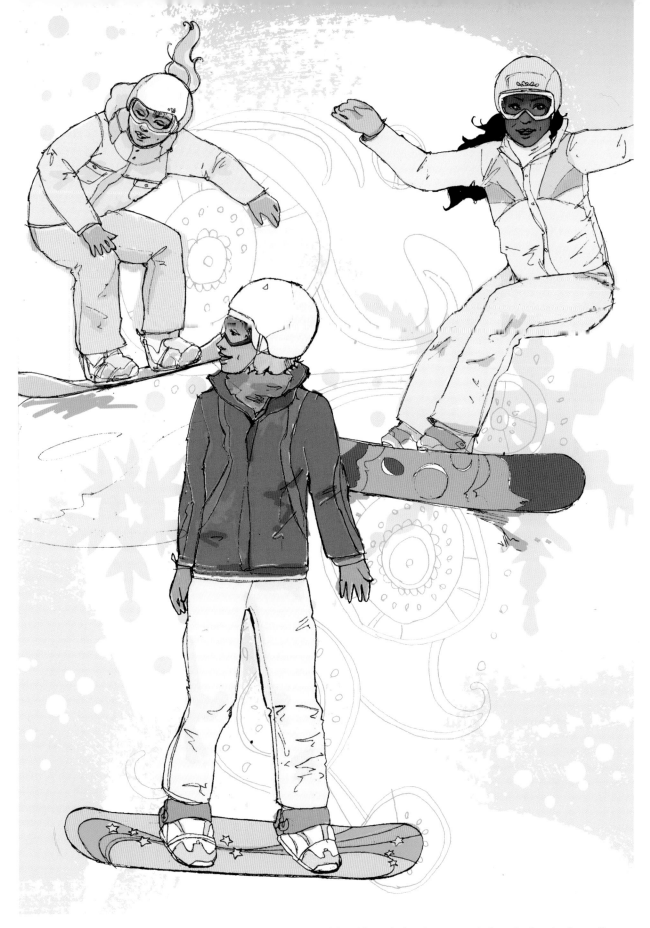

Sport: Sports illustrations can be used for books, events or magazine articles; this particular piece was part of a series for a book on action sports. Drawing sports figures in action is challenging and fun, and gives you potential for commercial work – take a look at sport or health magazines in your local bookshop and see which ones use illustrations. You could illustrate an article or a feature to help you practise incorporating a narrative or a theme into your work.

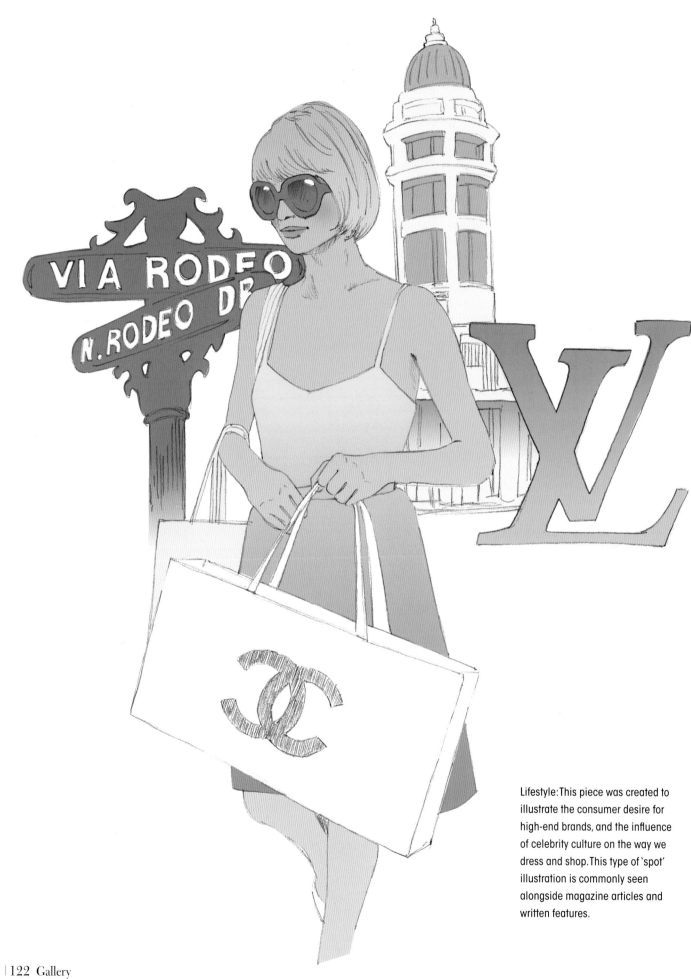

Lifestyle: This piece was created to illustrate the consumer desire for high-end brands, and the influence of celebrity culture on the way we dress and shop. This type of 'spot' illustration is commonly seen alongside magazine articles and written features.

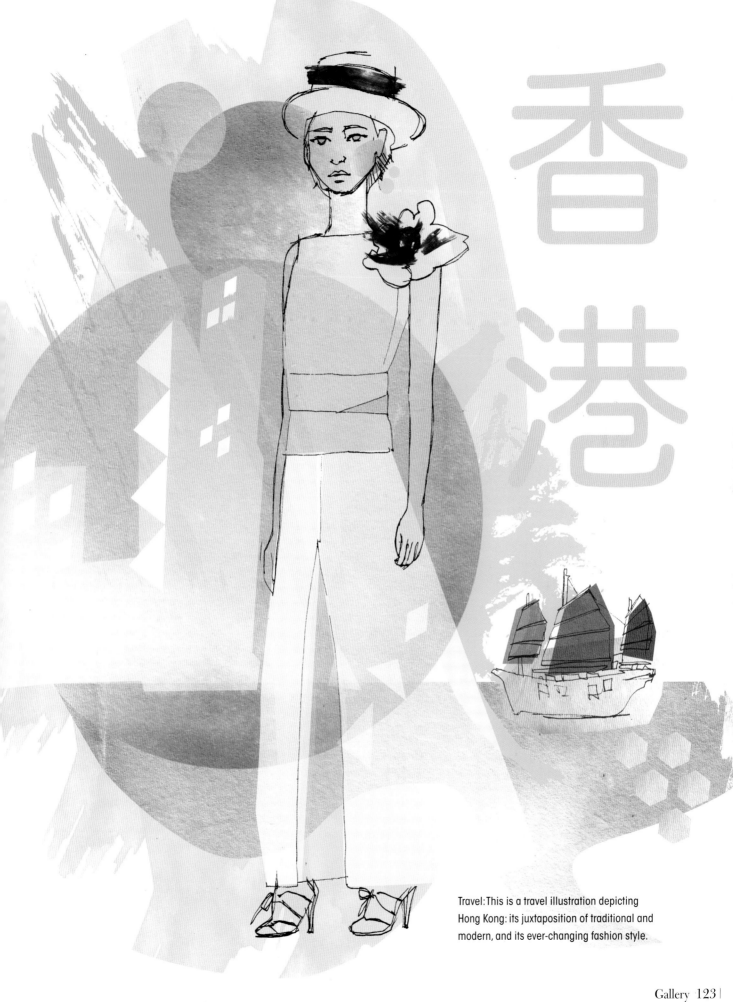

香港

Travel: This is a travel illustration depicting
Hong Kong: its juxtaposition of traditional and
modern, and its ever-changing fashion style.

USEFUL CONTACTS

Agencies

Anna Goodson Illustration (USA)
www.agoodson.com

Central Illustration Agency (UK)
www.centralillustration.com

Debut Art (UK and USA)
www.debutart.com

Dutch Uncle (UK, USA, Japan)
www.dutchuncle.co.uk

Eye Candy (UK and USA)
www.eyecandy.co.uk

Folio Art (UK)
www.folioart.co.uk

Handsome Frank (UK)
www.handsomefrank.com

Heart Illustration Agency (UK and USA)
www.heartagency.com

Illustration Web (UK)
www.illustrationweb.com

The Organisation (UK and USA)
www.organisart.co.uk

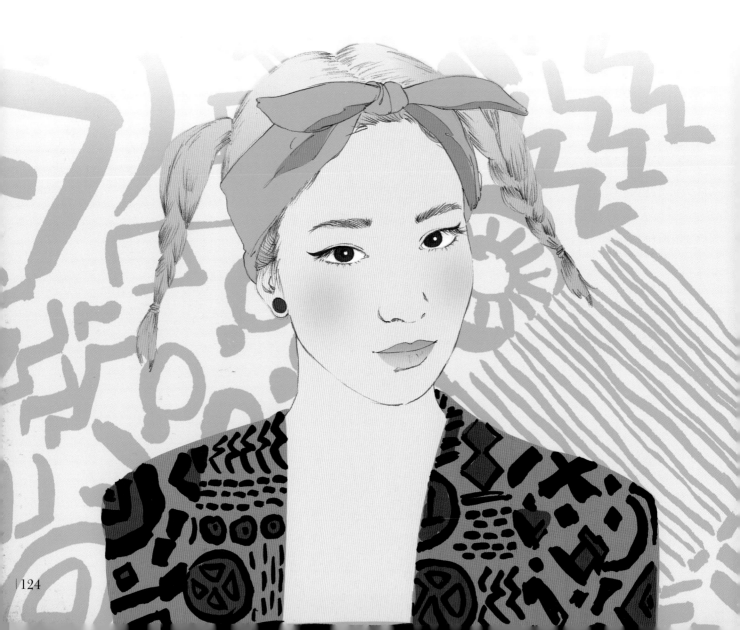

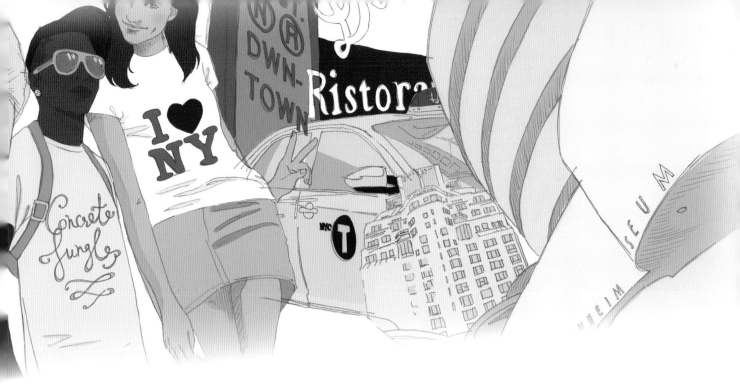

Organizations and blogs

Ape on the Moon (UK)
www.apeonthemoon.com

Association of Illustrators (UK)
www.theaoi.com

Communication Arts (USA)
www.commarts.com

Illustration Age (International)
www.illustrationage.com

Illustration Friday (International)
www.illustrationfriday.com

Illustration Mundo (International)
www.illustrationmundo.com

Little Chimp Society (International)
www.thelittlechimpsociety.com

Juxtapoz (USA)
www.juxtapoz.com

Pikaland (International)
www.pikaland.com

Society of Illustrators (USA)
www.societyillustrators.org

The Society of Artists' Agents (UK)
www.saahub.com

International annuals

American Illustration
www.ai-ap.com

AOI Images
www.aoiimages.com

Communication Arts
www.commarts.com

Creative Review
www.creativereview.co.uk

D&AD
www.dandad.org

Le Book
www.lebook.com

The I-Spot
www.theispot.com

3x3
www.3x3mag.com

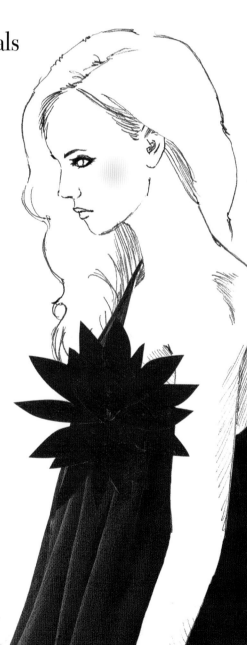

ACKNOWLEDGMENTS

I would like to thank F&W Media International for giving me the opportunity to work on this exciting project, and for all the fantastic support they have provided throughout this process. It has been an incredibly exciting, challenging and enjoyable opportunity. I would also like to thank my wonderful family for always supporting and nurturing my creativity, and my husband who continually inspires me with his incredible artistic talents. I would also like to thank my friends and my fans. Thank you!

ABOUT THE AUTHOR

Erica Sharp is a freelance fashion and lifestyle illustrator from London, UK. Her illustrations are a combination of hand-drawn, mixed media and digital elements, as well as handcrafted collages and paintings. Erica has illustrated for a variety of different projects and clients, including Anova books, National Magazines Company, Action Sports Media, and A & C Black Ltd. She is inspired by fashion, travel and nature.

INDEX

A DAVID & CHARLES BOOK
© F&W Media International, Ltd 2014

David & Charles is an imprint of F&W Media International, Ltd
Brunel House, Forde Close, Newton Abbot, TQ12 4PU, UK

F&W Media International, Ltd is a subsidiary of F+W Media, Inc
10151 Carver Road, Suite #200, Blue Ash, OH 45242, USA

Text and Designs © Erica Sharp 2014
Layout © F&W Media International, Ltd 2014

First published in the UK and USA in 2014

Erica Sharp has asserted her right to be identified as author of this work in
accordance with the Copyright, Designs and Patents Act, 1988.

A catalogue record for this book is available from the British Library.

ISBN-13: 978-1-4463-0436-5 paperback
ISBN-10: 1-4463-0436-1 paperback

Printed in China by RR Donnelley for:
F&W Media International, Ltd
Brunel House, Forde Close, Newton Abbot, TQ12 4PU, UK

10 9 8 7 6 5 4 3 2 1

Acquisitions Editor: Verity Graves-Morris
Desk Editor: Emma Gardner
Project Editor: Freya Dangerfield
Art Editor: Jodie Lystor
Production Manager: Beverley Richardson

F+W Media publishes high quality books on a wide range of subjects.
For more great book ideas visit: www.stitchcraftcreate.co.uk